ARE YOU REALLY MY FRIEND?

DEDICATION

For my nephew,
Henry Wilde Hollander

As a newborn, he rarely cried, but when he did, he was comforted by peering out
a window—his little feet resting on the sill and his nose pressed against the glass.

As a one year old, he picked up his purple guitar to write a song with me about our
favorite activity—blowing bubbles—which he aptly named *The Bubbles Song.*

Shortly after his second birthday, we went for a ride on a Ferris wheel. "What do you
see, Henry?" I asked, and he exclaimed, "We're in the sky, whoa! Look, look, look
at that. Look, look at all the cars! We're in the sky! We're in the sky!"

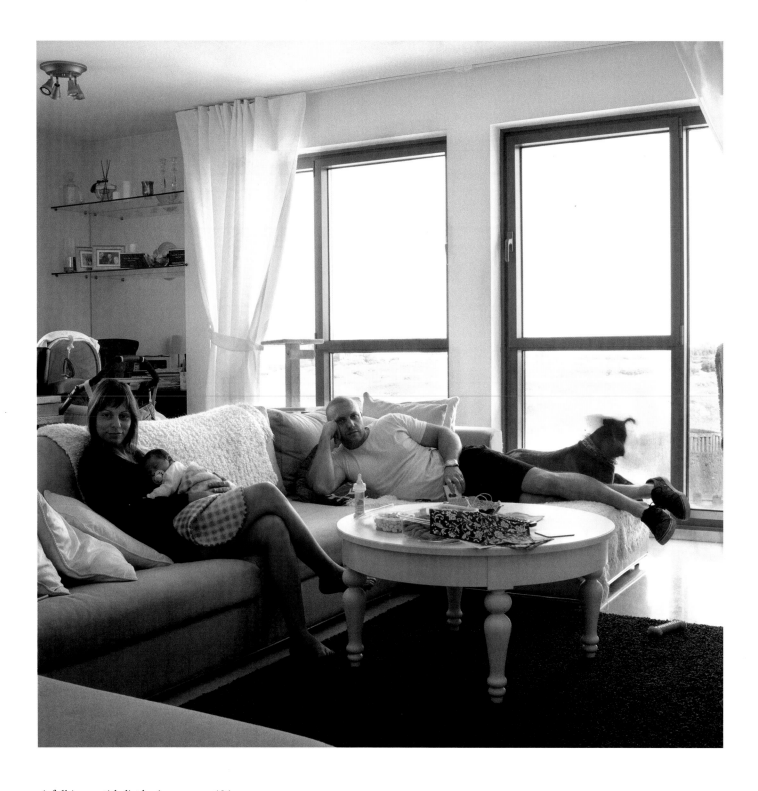

A full image title list begins on page 194.

INTRODUCTION

On New Year's Eve 2010, Tanja Hollander was in her kitchen in Auburn, Maine, simultaneously writing to two friends: one deployed in Afghanistan, with whom she corresponded via pencil on paper; the other working in Jakarta, to whom she sent a Facebook message. In this moment, between the tangible and digital, Hollander decided to photograph all 626 of her Facebook friends in real life. The journey began in Washington, DC, in March 2011 and ended in Tel Aviv, Israel, on June 4, 2016. During this time, Hollander immersed herself in the lives and communities of both close friends and virtual strangers, all the while sating her curiosity about the differences between the analogue and digital lives we lead.

Are you really my friend? is a vast project featuring 430 portraits, photographs of landscapes Hollander visited, snapshots and videos of what she experienced along the way, images of travel ephemera, a short documentary, and an interactive Post-it note project. For the portraits, Hollander set up traditional sittings with a Hasselblad medium-format film camera; however, she also documented everything using her point-and-shoot camera and iPhone. The utilization of film, and shooting with only available light, was deliberate, allowing her to travel lightly and unobtrusively. Much as in real life, some images are drenched in sunlight, while others are barely lit by a single ceiling-fan light bulb on a gloomy day. Additionally, Hollander scanned each piece of ephemera gleaned over the past six years against a colored backdrop. No image, no object, no experience is taken for granted, an ethos that filtered into the making of this project.

It was important to Hollander that viewers should understand her entire experience—a stipulation of the social media age. AYRMF takes a defiant stand against the art world, showing that a careful selection of portraits is perhaps no more important than an iPhone snapshot, a scanned boarding pass, or travel spreadsheet. In March 2017, an exhibition of the finished project opened at MASS MoCA. Throughout the run of the exhibition, Hollander's friends have visited and taken pictures in front of their portraits—children have grown up, people have passed away, and we can feel time moving forward like a living Facebook wall.

Now, this book is the latest iteration of the project. In it, she articulates the challenges and pleasures of integrating social media into her creative practice—including how to navigate the complexities of maintaining a private life while engaged in such a public project. Short essays by contributors Elisa Albert, Jacoba Urist, and Wendy Richmond deepen and extend these themes: Albert by investigating the potentially ephemeral nature of friendship in a digital age, Urist by analyzing the ways in which class disparity shapes our daily interactions, and Richmond by celebrating the real and lasting friendships collected along the way. Hollander's own writings and documentation of the six-year project are dispersed throughout.

During this venture, Hollander's determination has been to lay everything bare, to remind us of the importance of friendship both in life and on line. She reminds us to collect the world on our own terms, to remember that a gas station egg sandwich is just as good as a French bakery croissant—and that while real friends may not exist, real friendship absolutely does.

—Denise Markonish

"Why did you save your trash?" my assistant Brittany asks, after she's spent weeks re-touching scans of travel ephemera: a map Lynn left for me detailing where to find her car in San Francisco; the lid to the cup of ramen noodles I bought, fighting a cold, when I was in Ghent to photograph Carl; a toothpick with Arabic writing from the flight to Kuala Lumpur to photograph Maury; a box that contained Plan B One-Step after a trip I'd rather not remember.

After six years of working on *Are you really my friend?* I had over 100,000 images. Plus, an enormous archive of e-mail correspondence, text messages, Facebook posts and messages, Tweets, Instagrams, monthly mailing-list updates, blog posts, and notes on my phone, computer, and journals. I'd amassed tens of thousands of Post-it notes on friendship from third graders in the South Bronx to PhD candidates at MIT, and from many people all over the world in between.

How to edit it down?

Looking at the Post-it notes, I identified these recurring key words: Trust, Unconditional, Need, Make, Know, Judge.

With those words in mind, I pulled images from the trips most important to me, and then stories to accompany the images. Some of the images are direct illustrations of text; others are looser interpretations.

And I began to create just *one* of many new stories that have emerged from doing this project about friends, and friendship, and how we stay connected (or don't).

Colin lives in Los Angeles and calls when he is stuck in traffic. Jenny and I mostly text, a pdf of our conversations over the last five years is 706 pages long. Kio and I met on Instagram, a professional relationship that turned deeply personal. I was determined to make Hasan my friend after I discovered his work online. Little did I know, I would become friends with his wife, Grace, too! Jeff B is my favorite person to see art with when I'm in New York. Joe and Katie made me the godmother of their children, Winona and Delila. Every time I'm in a glass elevator, I text Wendy a video because it reminds me of the afternoon we rode in one together. Emily sends thoughtful cards. Shara feeds me a delicious meal. Gideon always greets me with the middle finger. Barry hides cash in my camera bag.

All these people, all these images, all these notes—they're all relevant. We weave in and out of each other's lives at different times, for different reasons, and that's okay. Friendship is messy and complex, rewarding and hilarious, genuine and fleeting.

—Tanja Hollander

From: Tanja Hollander
Subject: reflections
Date: April 26, 2016 at 6:22 PM EDT
To: Robin Greenspun

So what's the difference between need and desire, between hope and faith?

Texas was the first time I felt alone. But did I need someone? I don't know.
Would it have been easier or better if there was someone else there with me, sharing
the experience? Probably. Is that what friendship is? What love is? Being alone,
but not lonely.

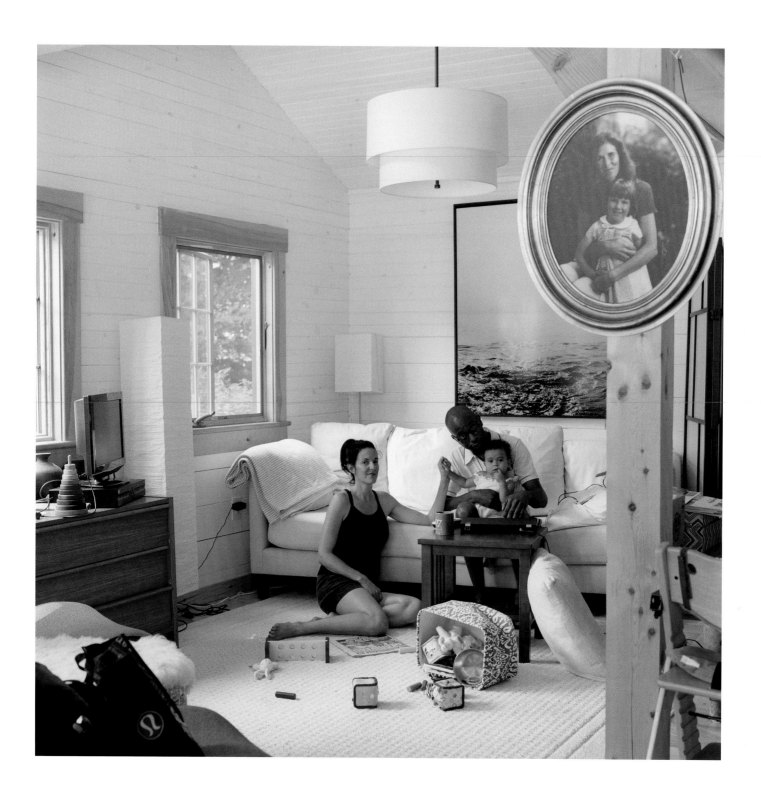

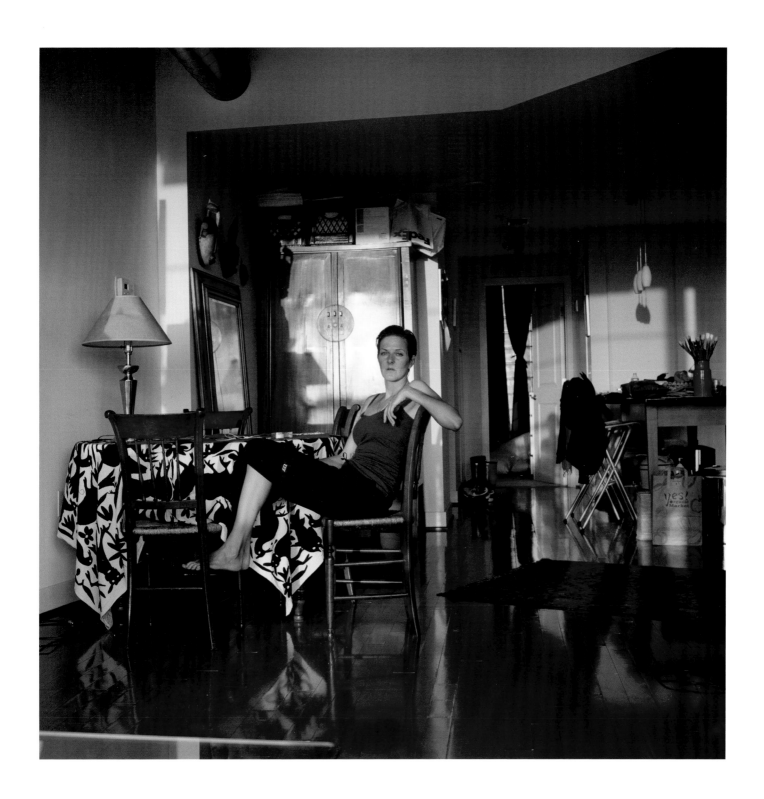

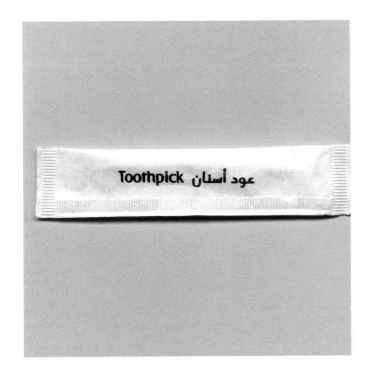

Toothpick عود أسنان

Someone who,
with interaction,
—subtle or profound,
makes your life
a better experience.

I wish I could photograph the smell of LA after it rains. #california

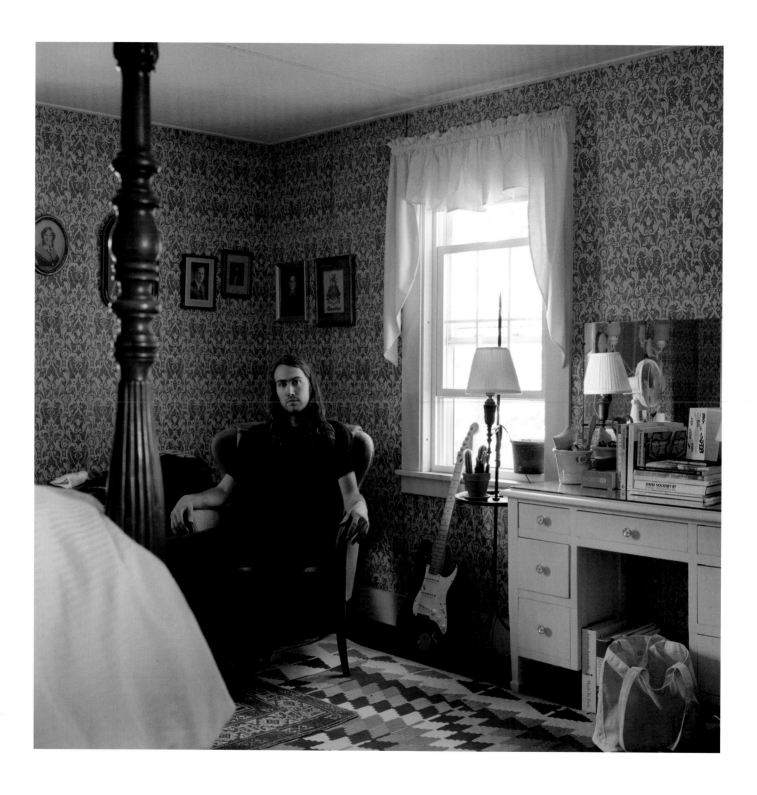

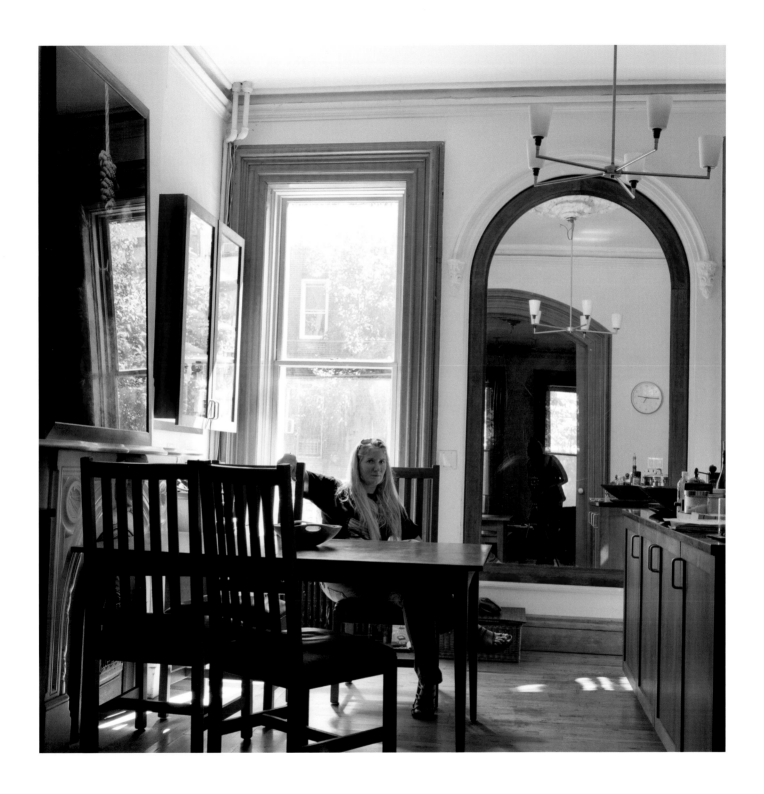

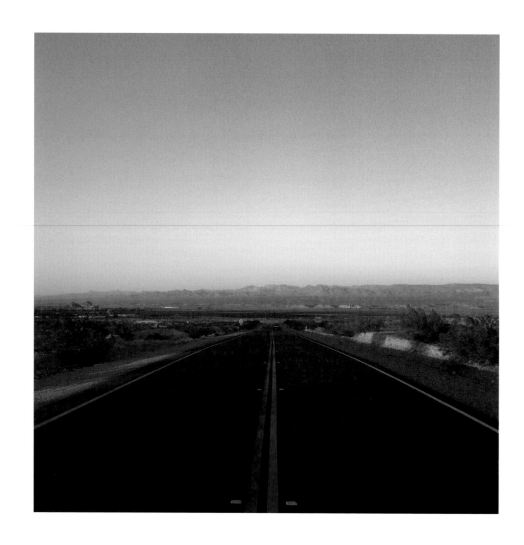

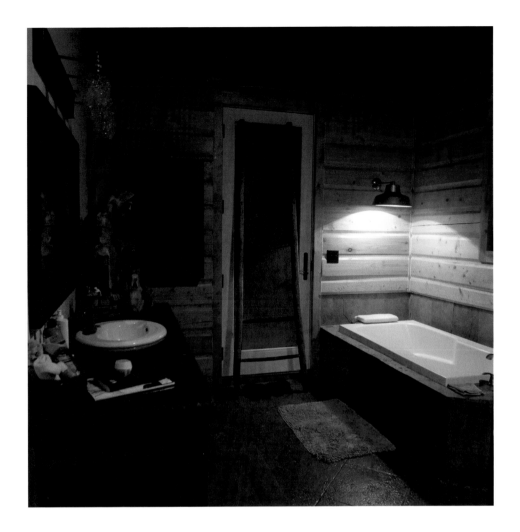

It takes me a couple of hours to drive from Oshkosh to Mountain, on a detour to meet friends I only know through social media. As I'm pulling onto their road, they call to say they've broken down, and they'll be a couple of hours behind me, so I should make myself at home.

I get out of the car. The sky is full of stars. I enter the key code and open the door to a beautiful hand-built cabin. I poke around for a few minutes, then decide to have a nice long bath. Running the bath, I hear a knock at the door. I'm not undressed yet, so I answer it. A friendly gentleman with a little dog comes in—he introduces himself as Craig and the dog as Peanut. We chat for a bit and he leaves.

As I'm lying in the tub, I realize I'm alone in rural Wisconsin and I just let a stranger into a stranger's house.

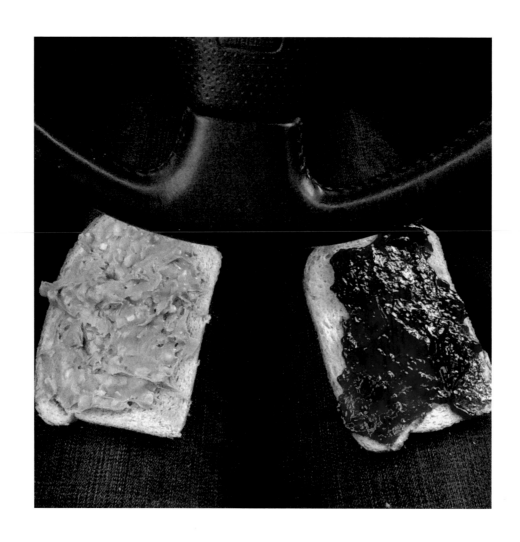

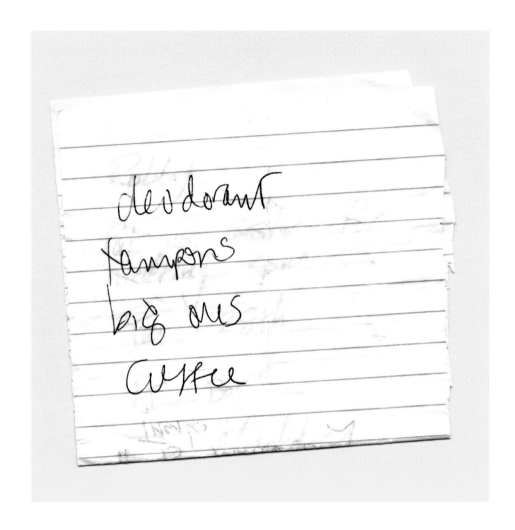

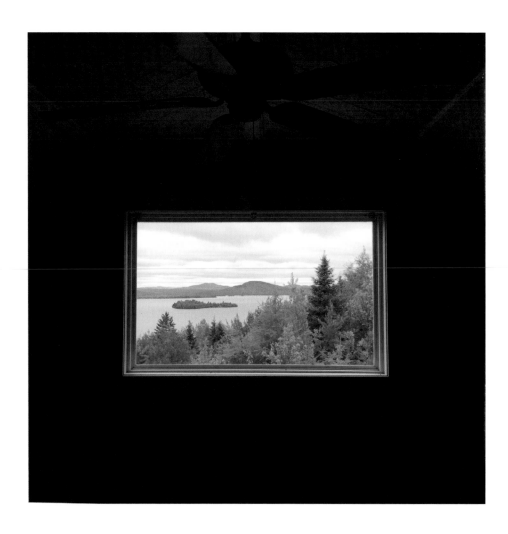

I stay with Ed and Dr. Mary so much they get me a bathrobe.

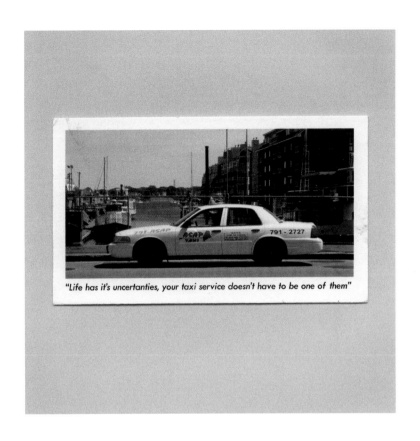

"Life has it's uncertanties, your taxi service doesn't have to be one of them"

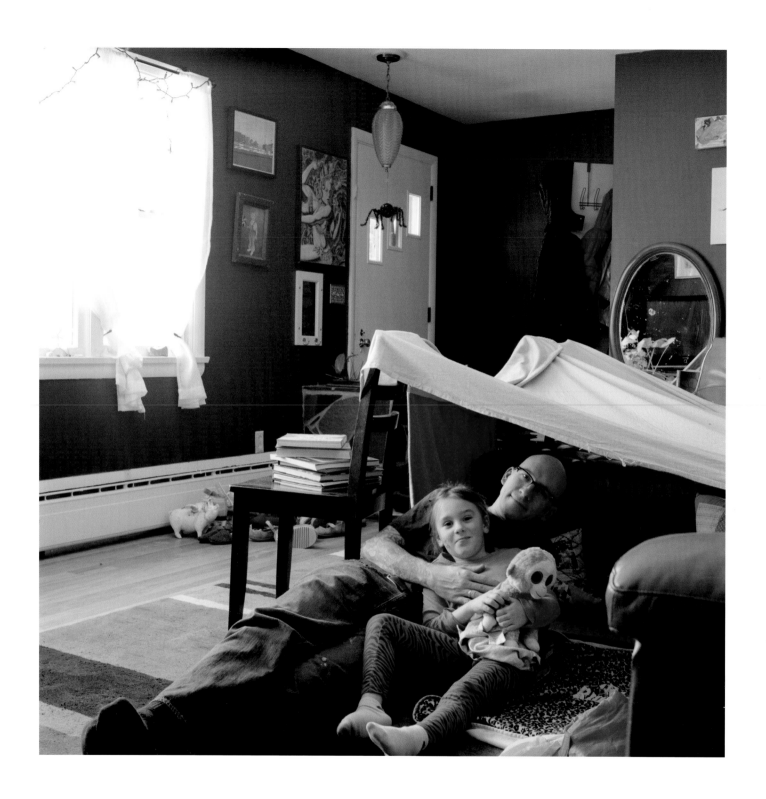

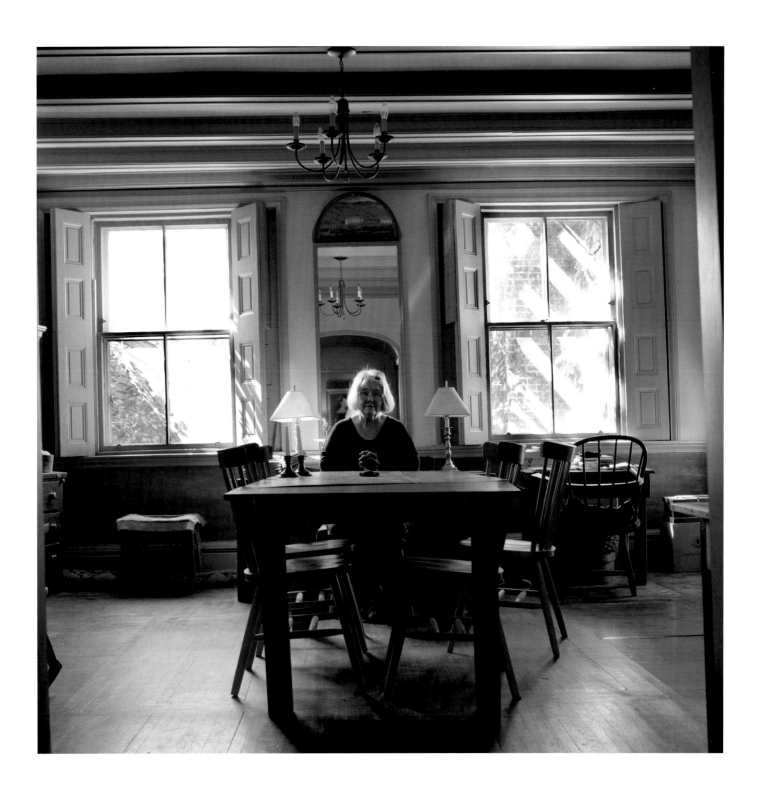

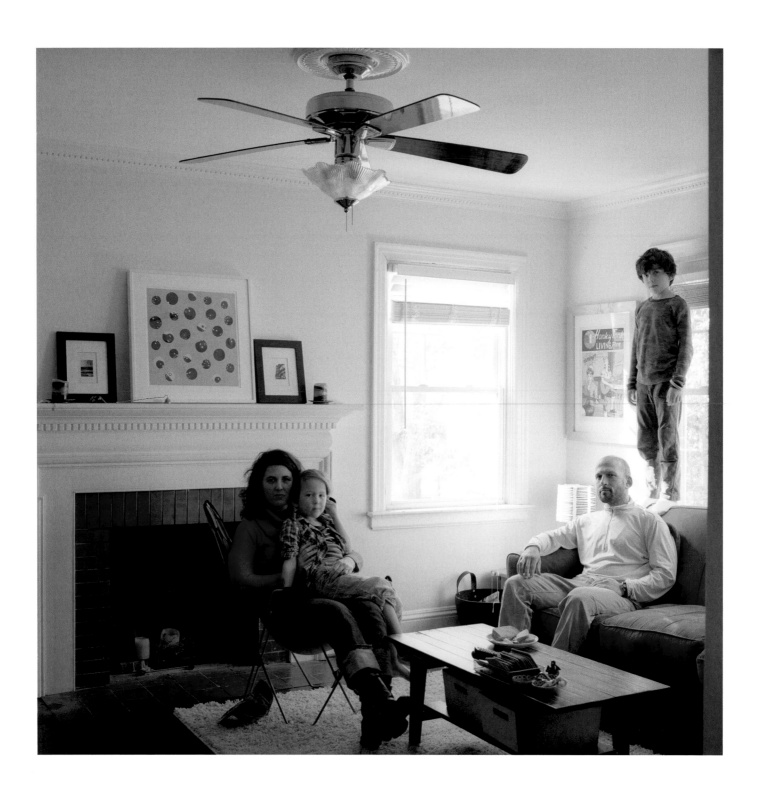

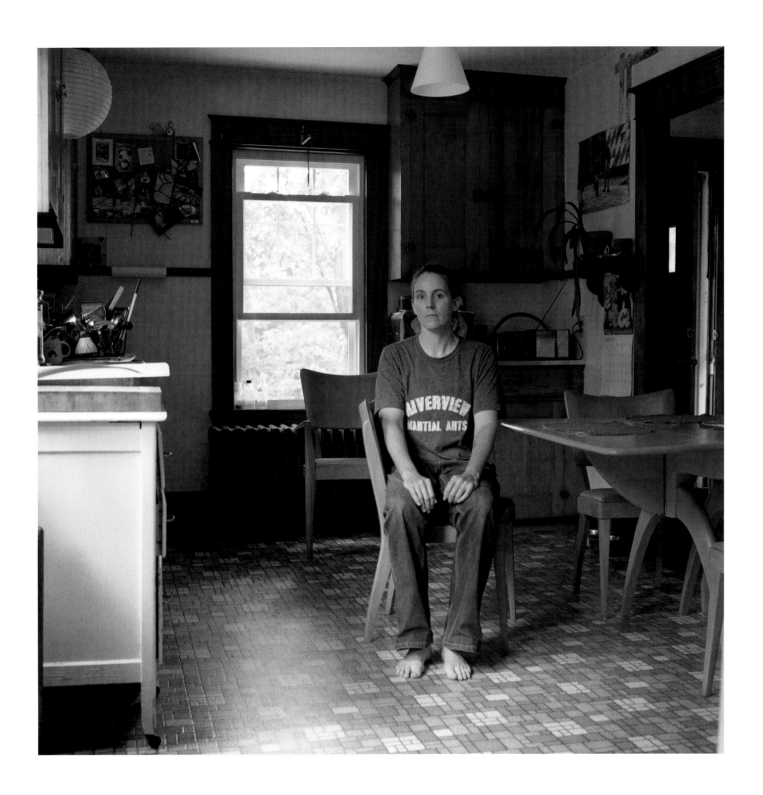

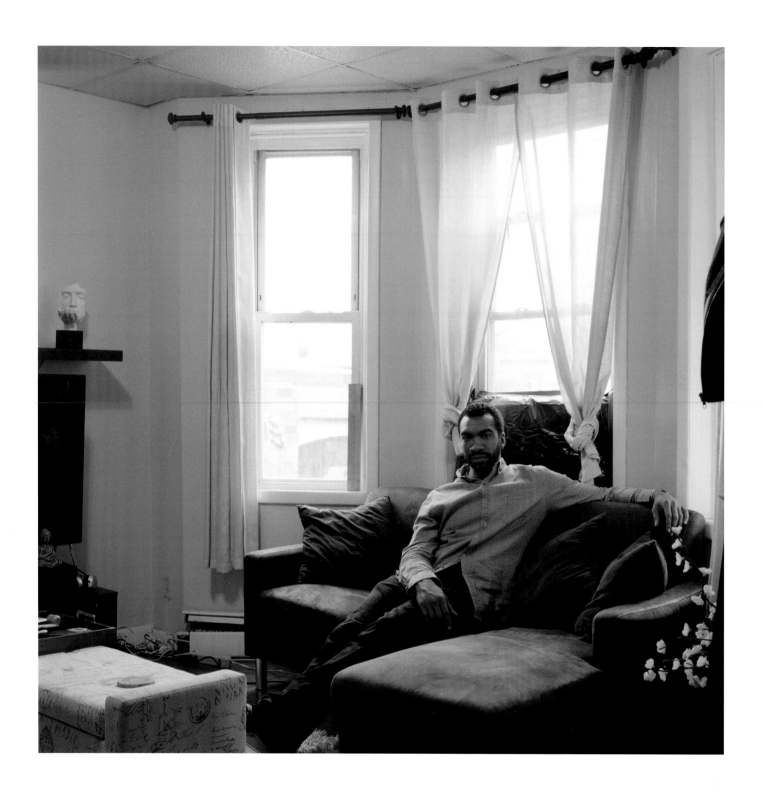

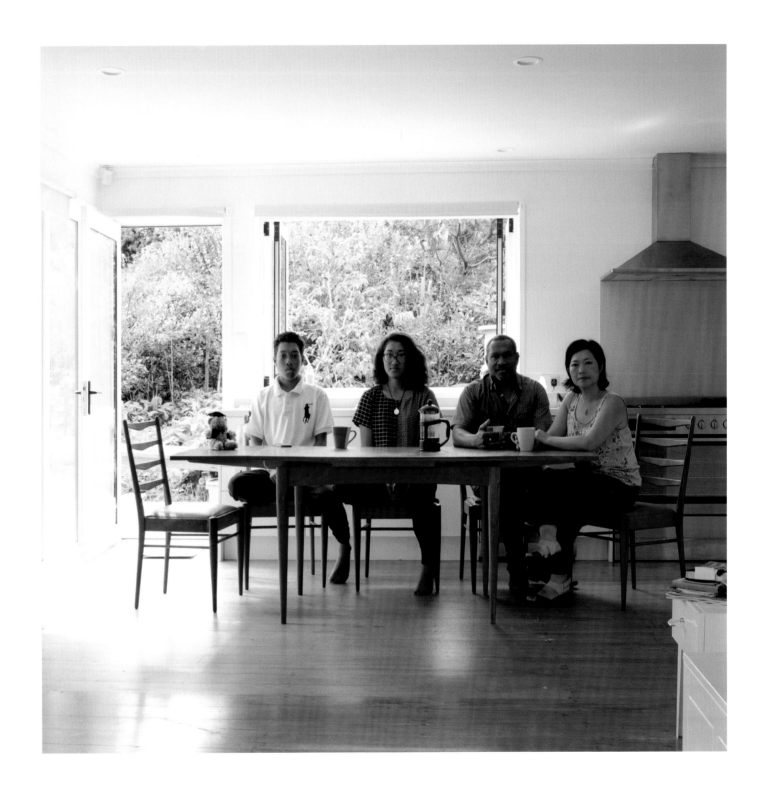

a real friend knows when you take your birth control! (1:35 PM)

A friend is: Someone who you can hang out with in your underwear.

a real friend does not judge your crazy.

My Rock

A real friend will make you a steak even if they are a vegetarian.

A real friend sticks by you even when you've had multiple affairs and divorced your wife.....

I'm standing next to an older black gentleman who's looking at a Lewis Hine photograph of a little girl working in a factory. Two girls, actually—he points out another one in the background. He initially mistakes me for his family, but then says to me anyway, "I need my grandson to see this. To see the importance of this photograph. To see the dangerous jobs children had to do." #artinstitute #chicago

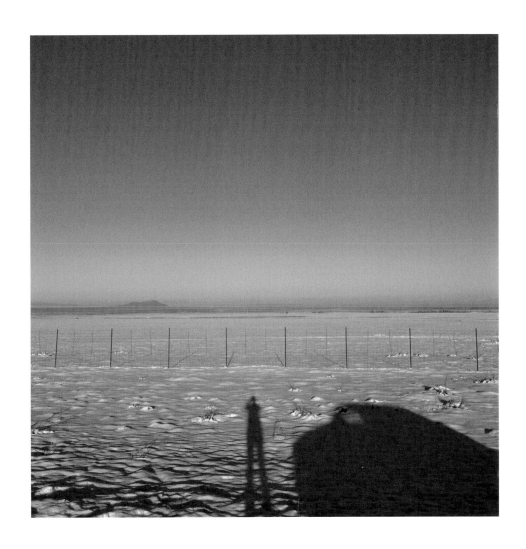

"So your job basically is to go around taking pictures of people doing nothing."
—Elise, age nine

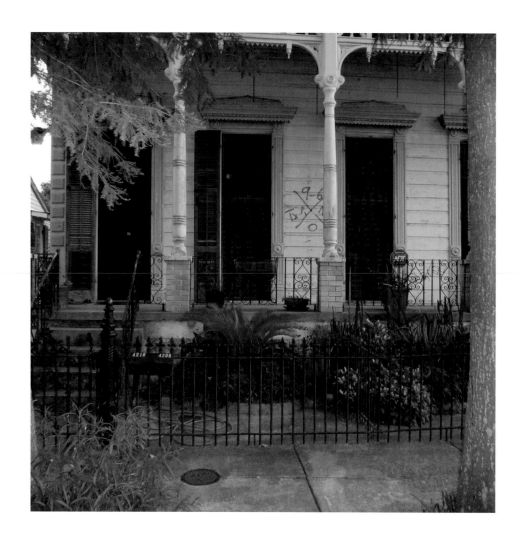

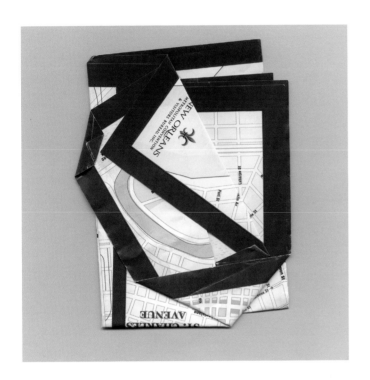

Some people choose to keep the post-Katrina spray painted "X" that lists dates and the number of dead on houses they are clearly living in. Like a scar you don't want to hide. #neworleans

What I learned today: pulling over on the side of the frozen highway to photograph is not safe, and driving across country to make portraits has gotten me excited about landscapes again.

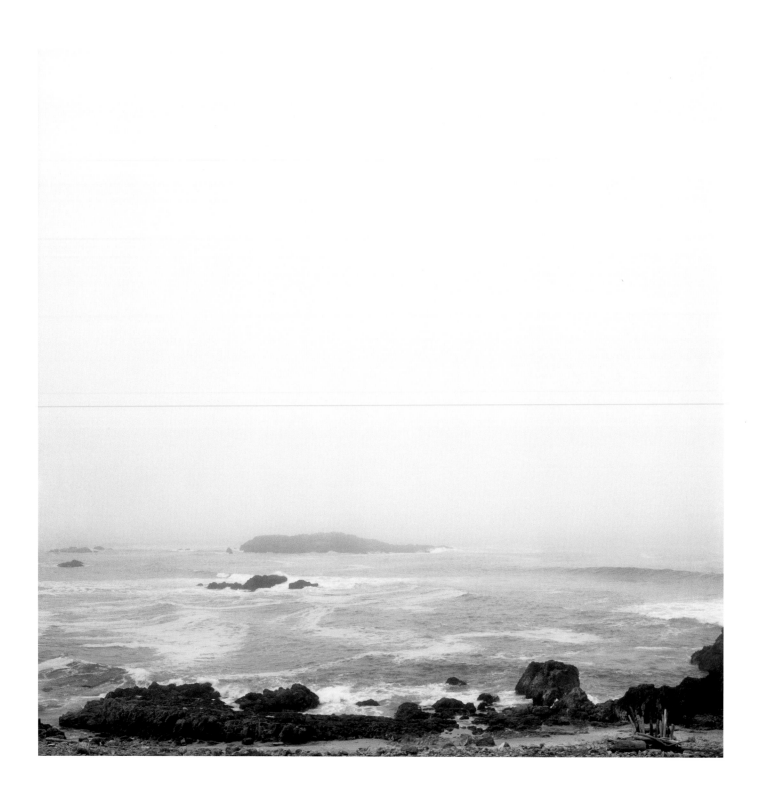

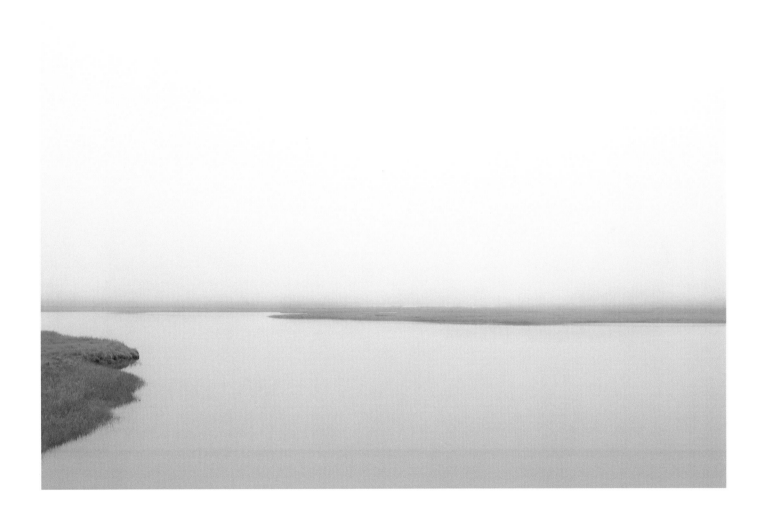

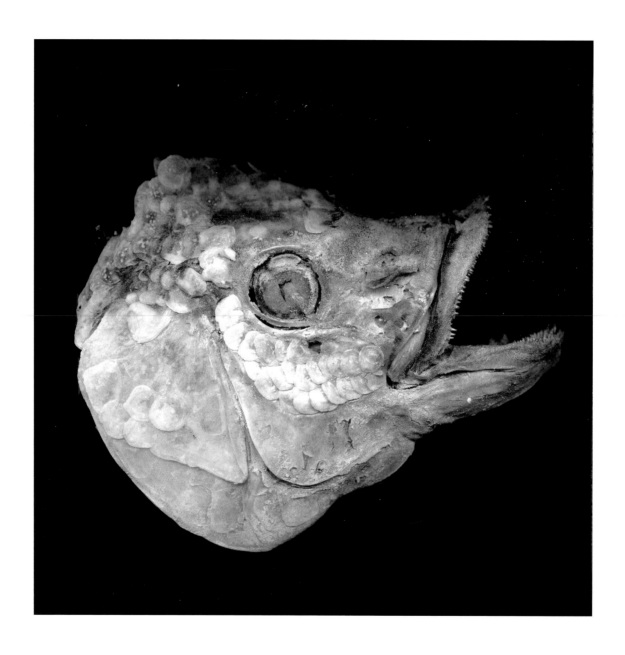

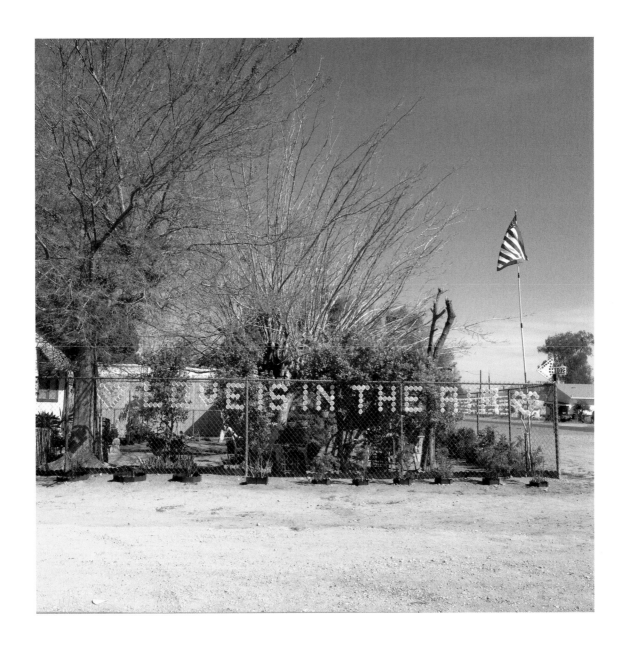

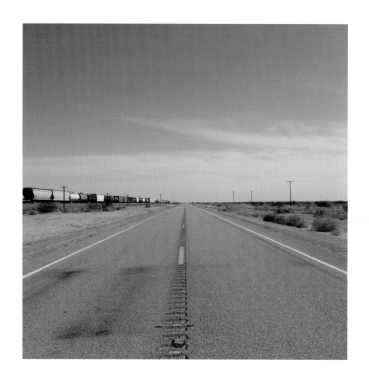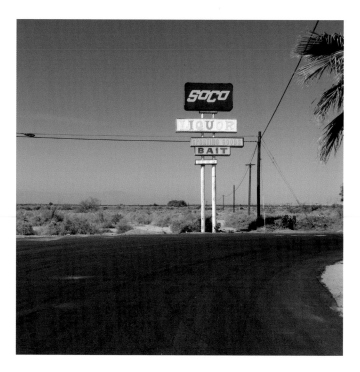

Perfect beach day—minus the smell, dead fish and color of the "water." What a depressingly beautiful place. #saltonsea

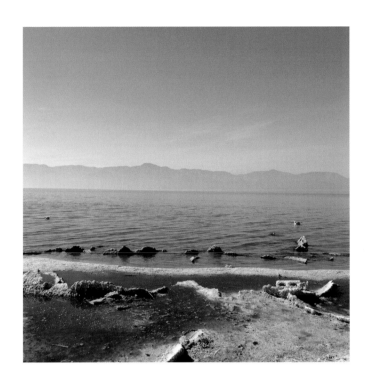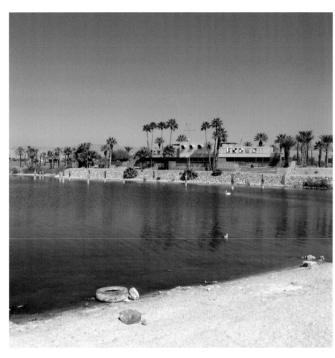

From: Scott Toney

Subject: RE: you really are my FB friend

Date: June 22, 2011 at 12:50:36 AM EDT

To: Tanja Hollander

Hey Tanja...hope you are well.

If you are coming out my way (to see your sister or something), I am living in Westford and on July 24th there is a bike-a-thon in my niece's name to raise awareness about domestic violence. It is in honor of my niece, Olivia, who was murdered last year by her father. Might be a bit more somber than you are looking for, but it is a slice of life, I guess.

Maybe I will see you anyway along the way? Best to you on your project.

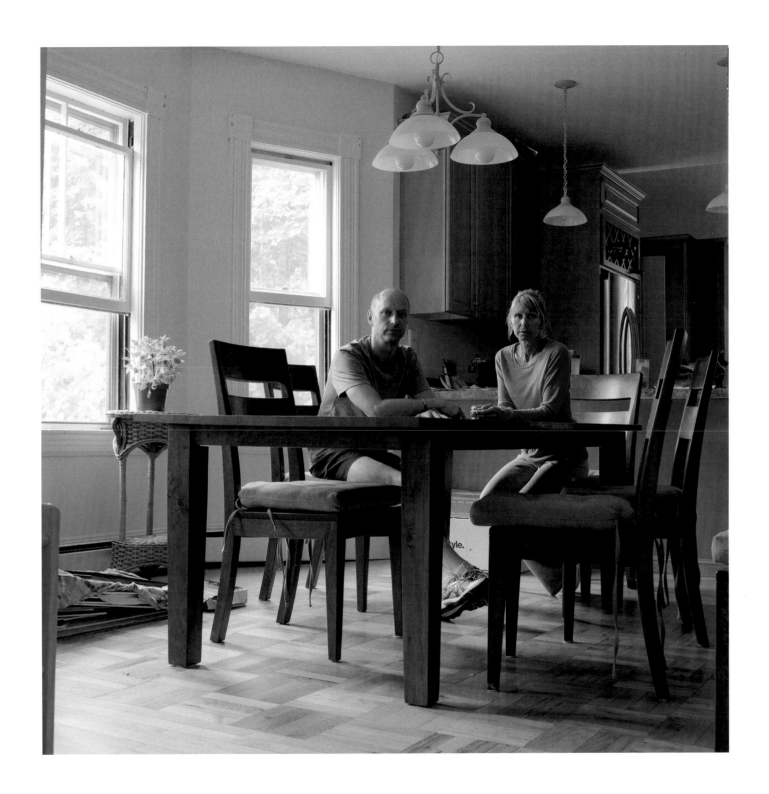

A freand is not a
bunny its not a toy.
a freand helps you
with education or your
war. a freand is not
a person you dont
know it is a person
who loves you to →

HELPS YOU
HOLD THE
SANITY
BUCKET

49

Nothing's real unless it's posted and tagged. And then, twenty minutes after it's posted and tagged, it's a drop in the ocean. What's worth anything? What matters? How are moments and relationships and sunsets etc. possibly meaningful if they're so ephemeral? It's a fucking thousand-car pile-up. And isn't everything ephemeral enough anyway, even if it's not tagged and posted? Is all the tagging and posting helping make things less ephemeral?

As for me, I want to participate, and I loathe the idea of participation. But mostly I want to participate. I'm only human! See also: fear of missing out. See also: keeping up with the Joneses. Also: life is lonesome. Even when you're lucky and all is swell, life is lonesome. And it's unthinkably lonesome when you're unlucky and all is not swell.

So. What to do, what to do. How to navigate. What are the rules? Write your own. Where are our spiritual guides? Probably irritating us because they post too much, or being invisible because they don't post enough.

We keep inventing new ways to stay exactly the same, we human animals. It's our thing: new and newer ways to make noise and distinguish ourselves and assert our hilarious li'l egos. It's what we do.

Someone the other day took a photo of your portrait of us up at MASS MoCA and texted it to me. The photo. Of your portrait. Of us, your Facebook friends. Is the circle complete now?

—Elisa Albert

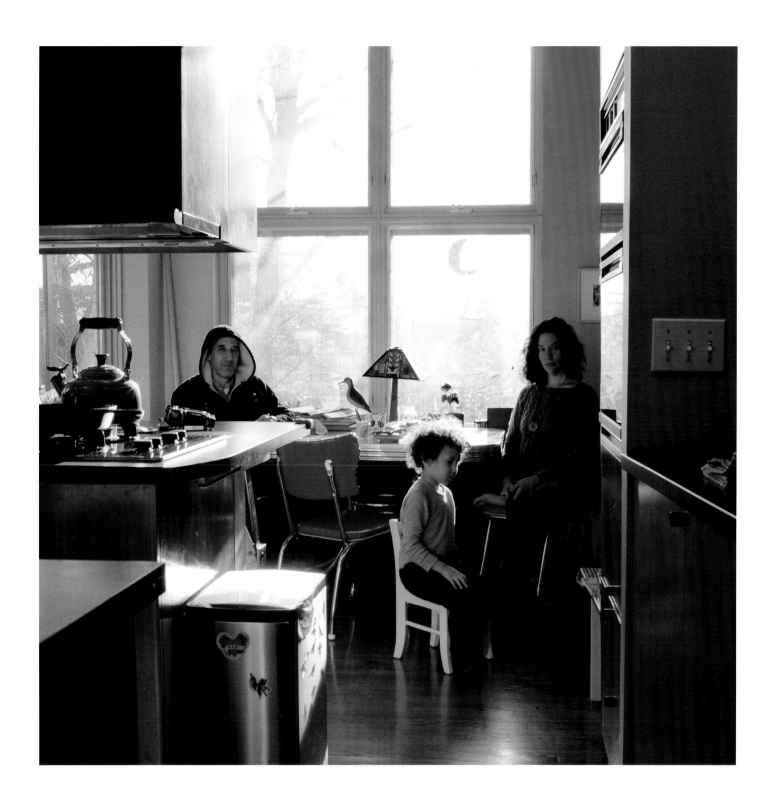

I just had my first outright "no" for a portrait from a friend of fifteen-plus years, something I wasn't at all prepared for. I assumed all my close friends would want to be part of the project, because they know how much it means to me, and how it has totally consumed my life. I got this sinking feeling that I had done something wrong, that I had offended him.

So, I e-mailed to try and repair the damage. He explained that he just didn't want to be part of the project, but that made me ask myself the question, am I cool with that? I decided I was (one less picture to make), because friendship shouldn't be based on cooperation with artists with hare-brained projects.

Which leads me to friend number two of fifteen-plus years— whom I did offend. I don't know how and I've been trying to figure it out, to apologize and repair the damage, for the last year. This week, it's his birthday. Seeing all of the activity around it on Facebook made me really, really sad not to be part of it.

Admittedly, I have a hard edge (my parents might say judgmental, my friends might say bitchy). But I've been trying to soften up a bit. I'm trying to be a better person and a better friend.

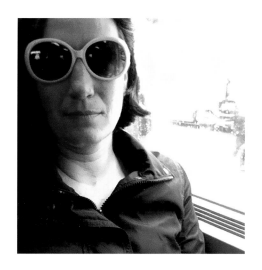

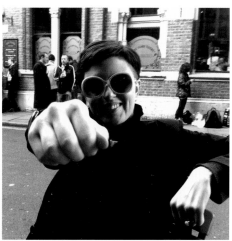

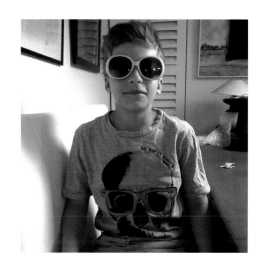

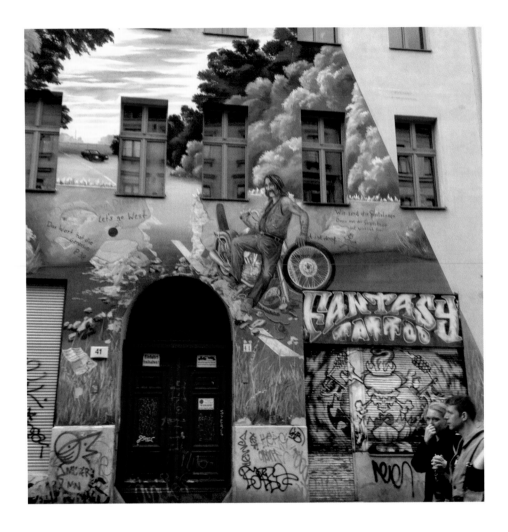

Arm wrestling champion, dive bar, Oshkosh. Broken glass, spilled beer, dog tags hitting the table. The wrestlers butt heads, embrace, push each other away and then draw each other close again. #wisconsin

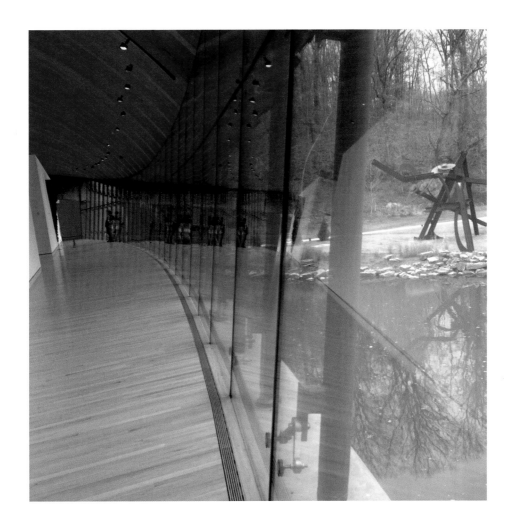

In Arkansas, at the museum founded by Alice Walton (Walmart heiress), I hear a mom explain who "Rosie the Riveter" is to her daughter in front of a Norman Rockwell painting. #crystalbridges

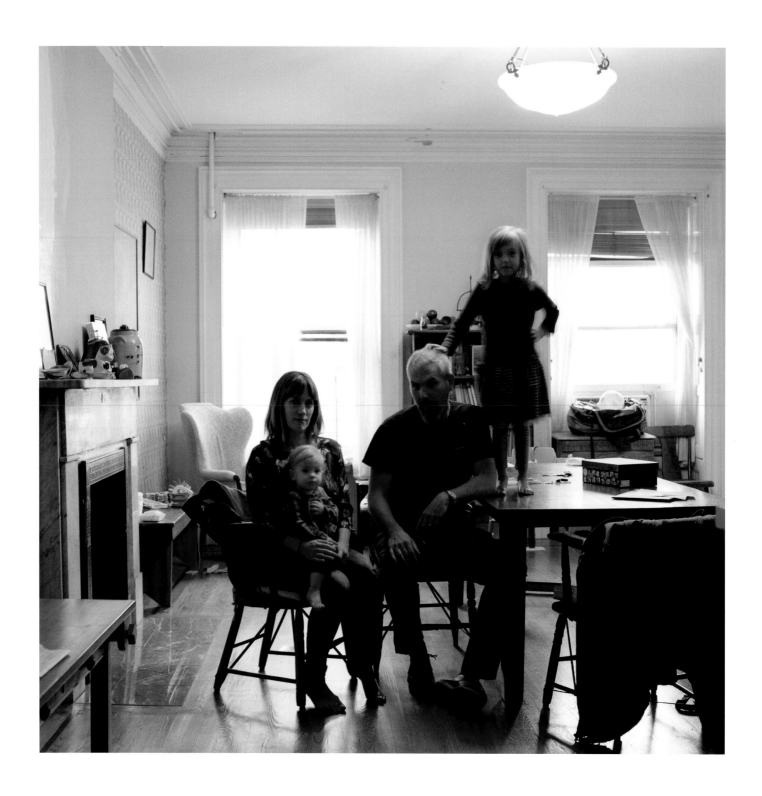

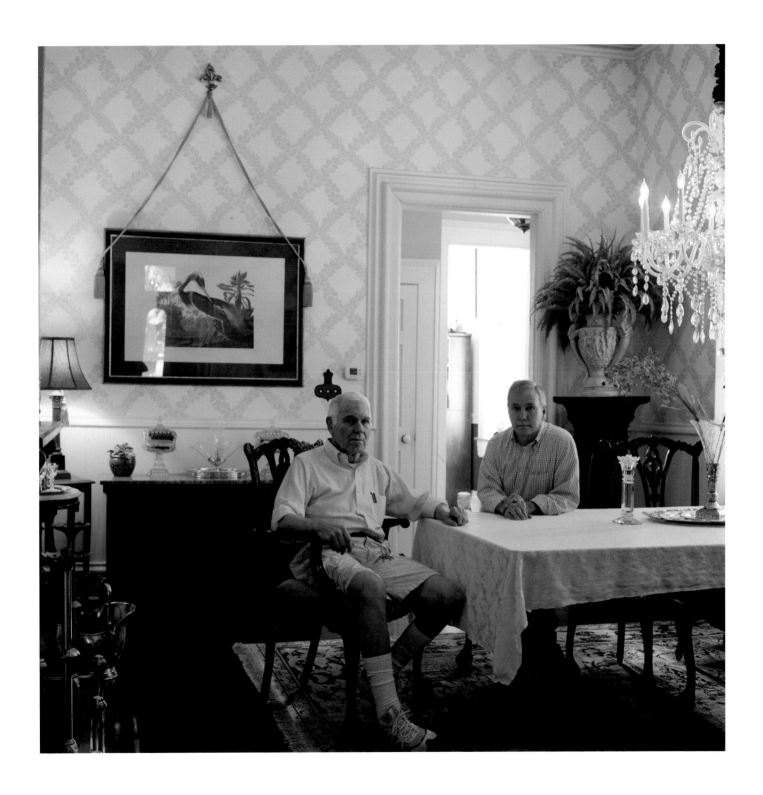

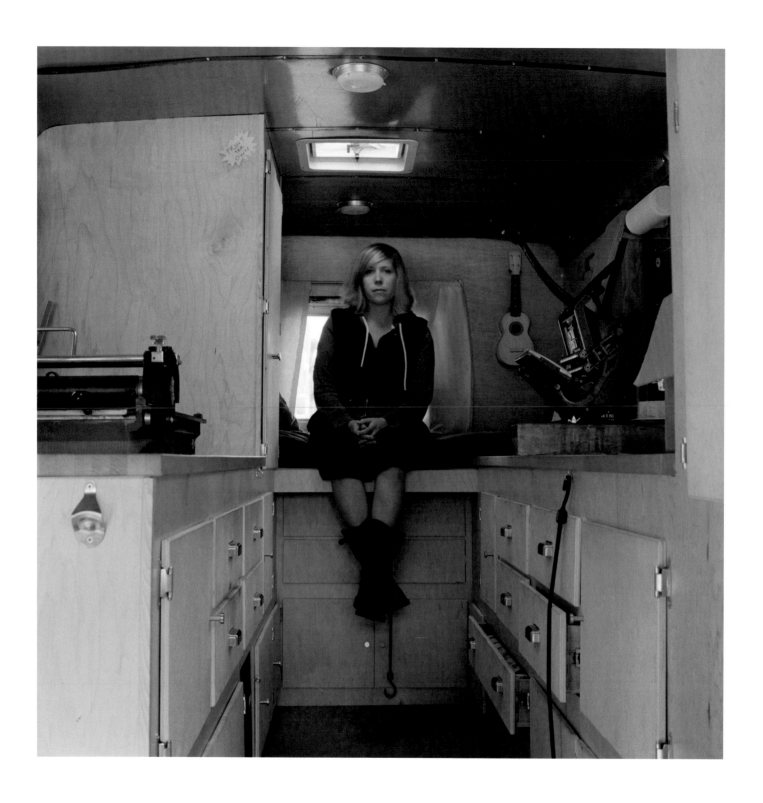

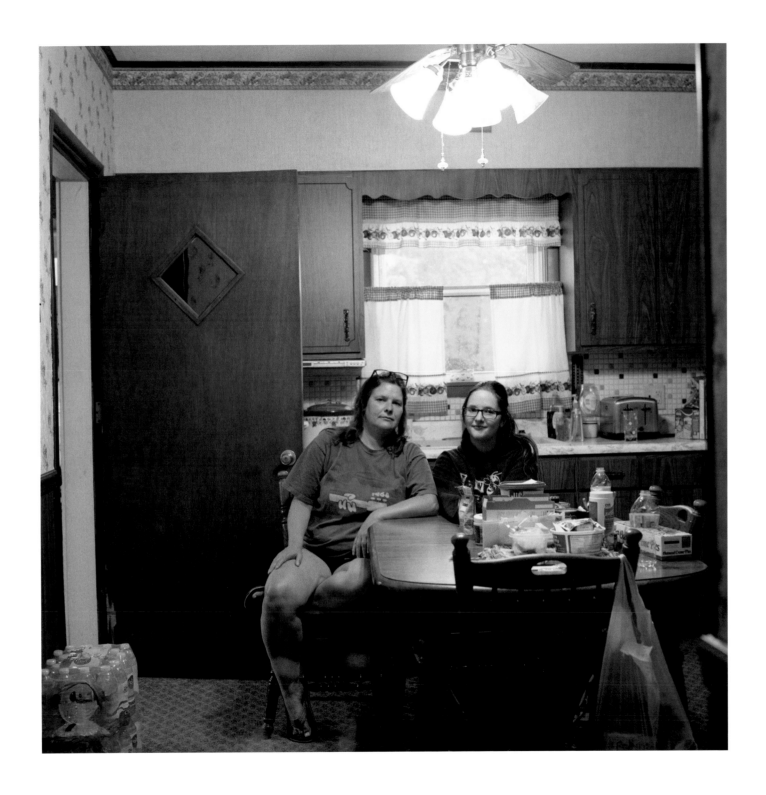

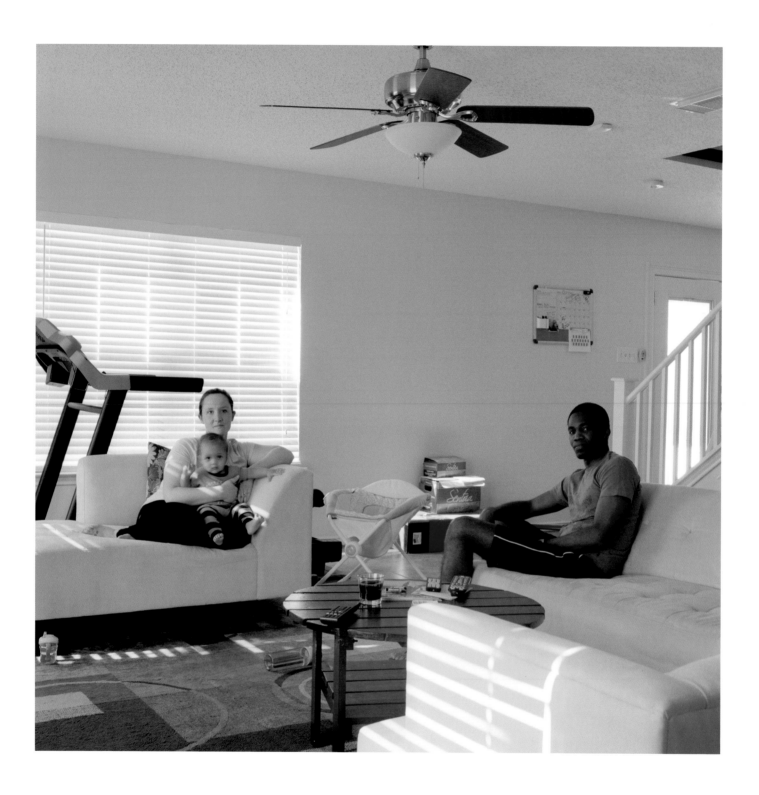

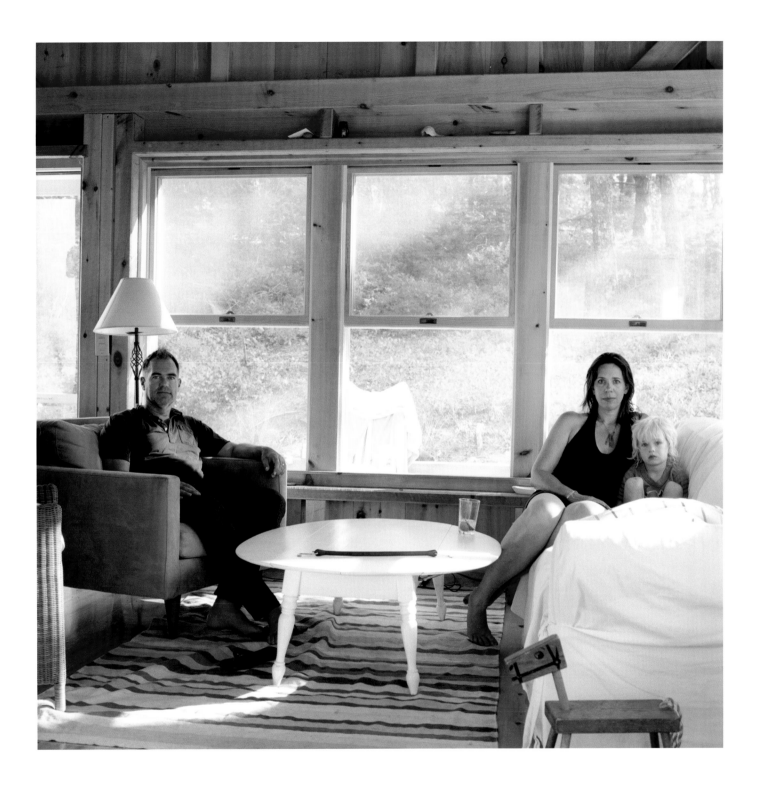

"I've decided my life's calling is collecting amazing people."
—Jenny

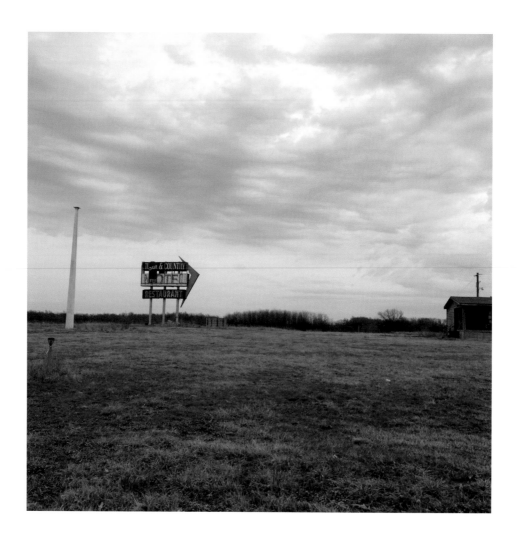

Southwestern Missouri: land of abandoned shops, pro-life billboards, cattle, and adult bookstores.

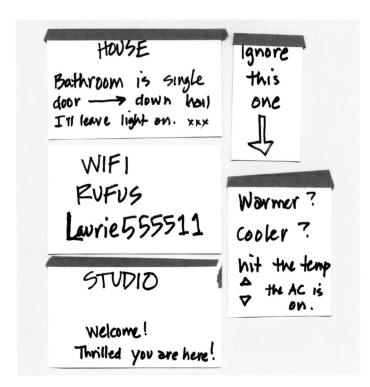

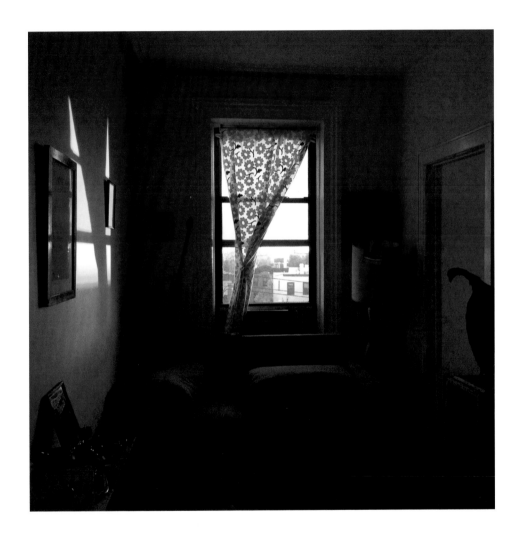

That split second when I wonder if I'm making myself at home in the right house.

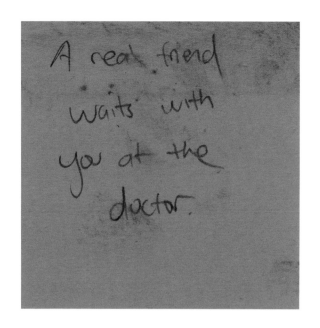

A real friend waits with you at the doctor.

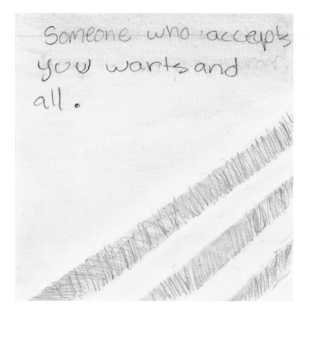

Someone who accepts you warts and all.

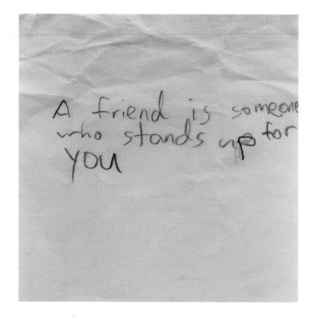

A friend would be someone who is willing, almost unconditionally to help you get through life. A friend would also never wish to actively harm you in one way or another.

A friend is someone who stands up for YOU

A real friend sends you 100 origami cranes she folded herself when you were diagnosed with leukemia

A real friend is someone you're partially in love with

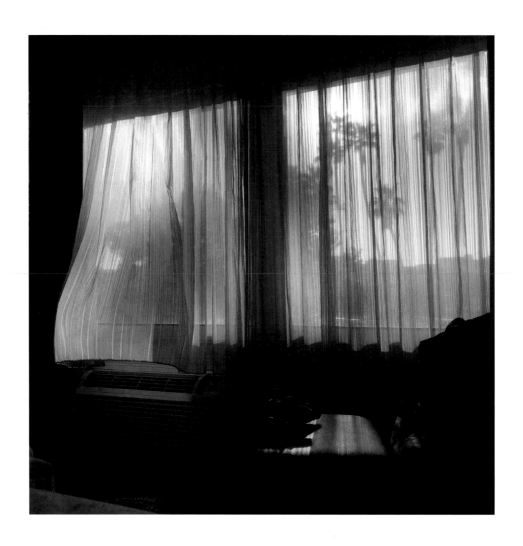

"Hey Tanja, come over here, it's a beautiful spot."
—Jack, age four

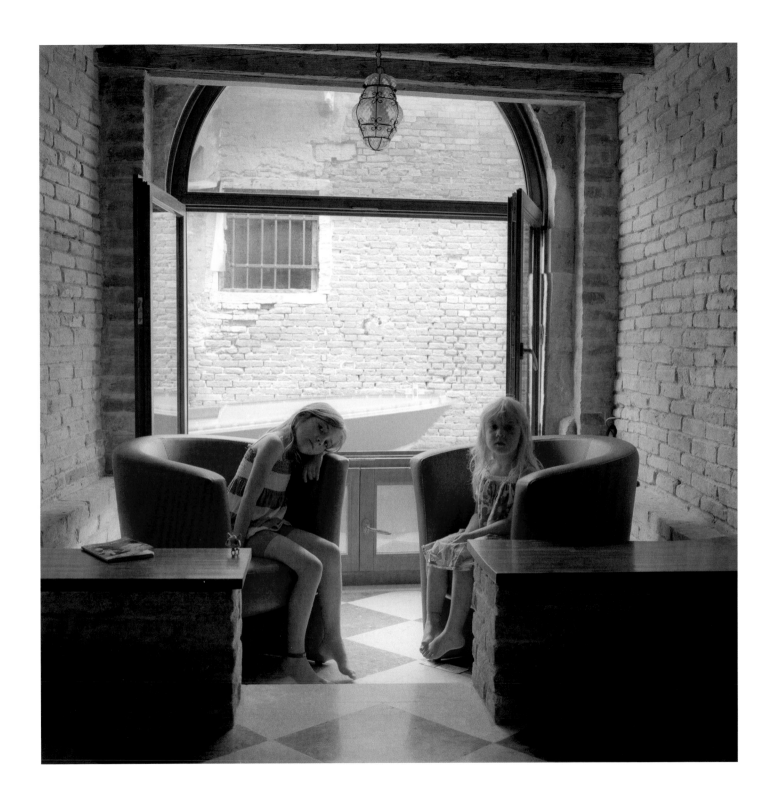

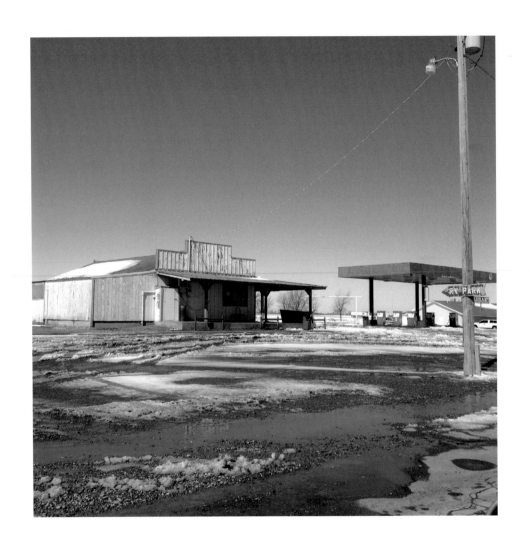

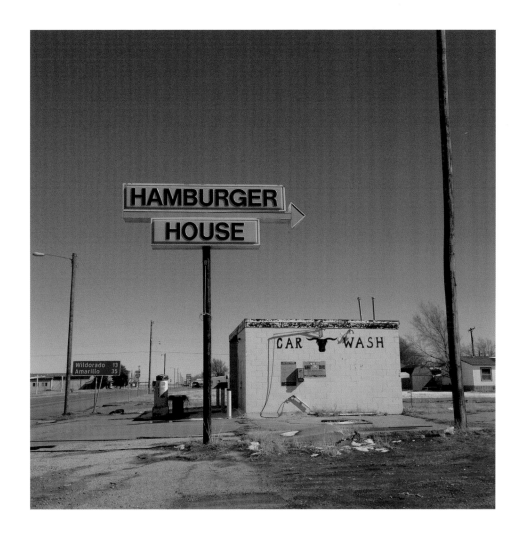

I stay on Route 66 for as long as I can. Deco motels and tchotchke shops turn to ghost towns. Isolation and despair. I dead end in a field. #oklahoma

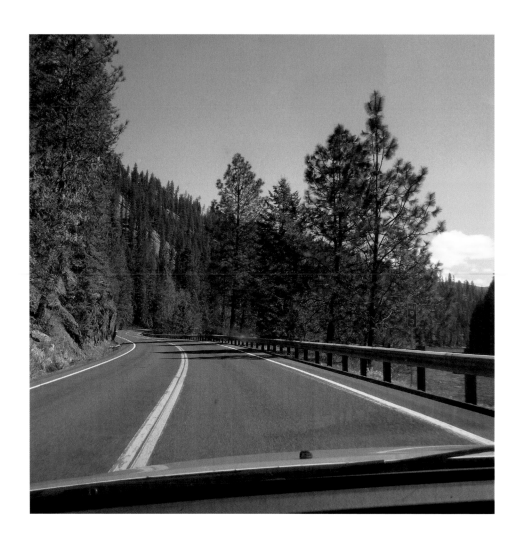

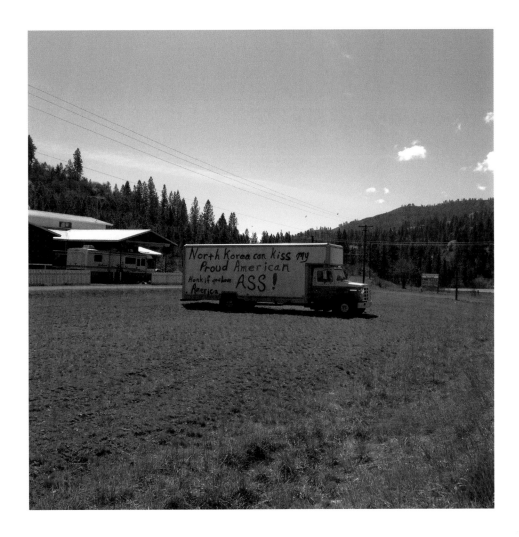

Idaho. That was an intense six hours of no cell service, past the roadside memorials, over the Bitterroot Mountains, through the Clearwater National Forest, and along the beautiful Lochsa River.

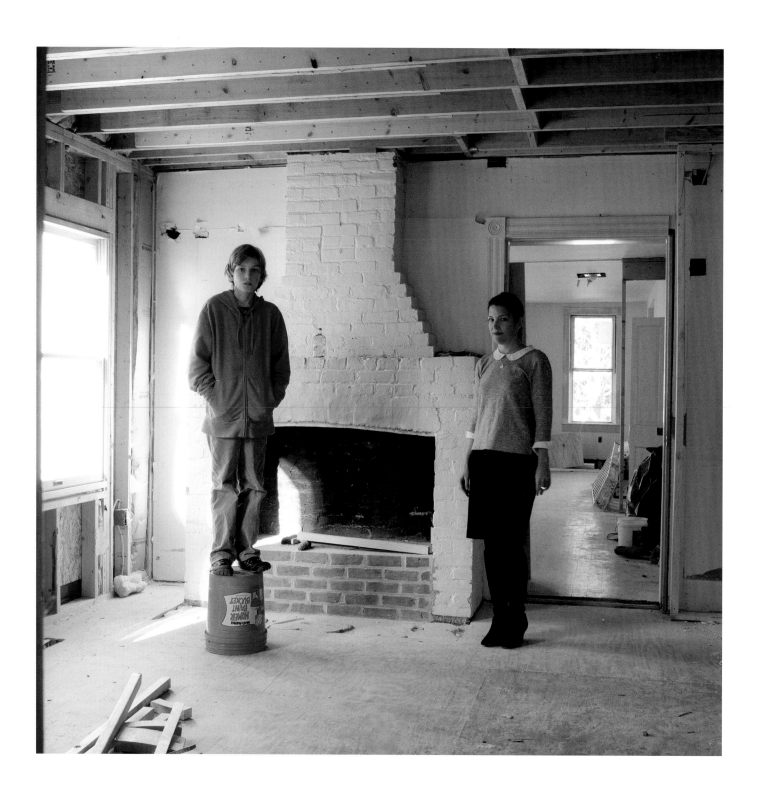

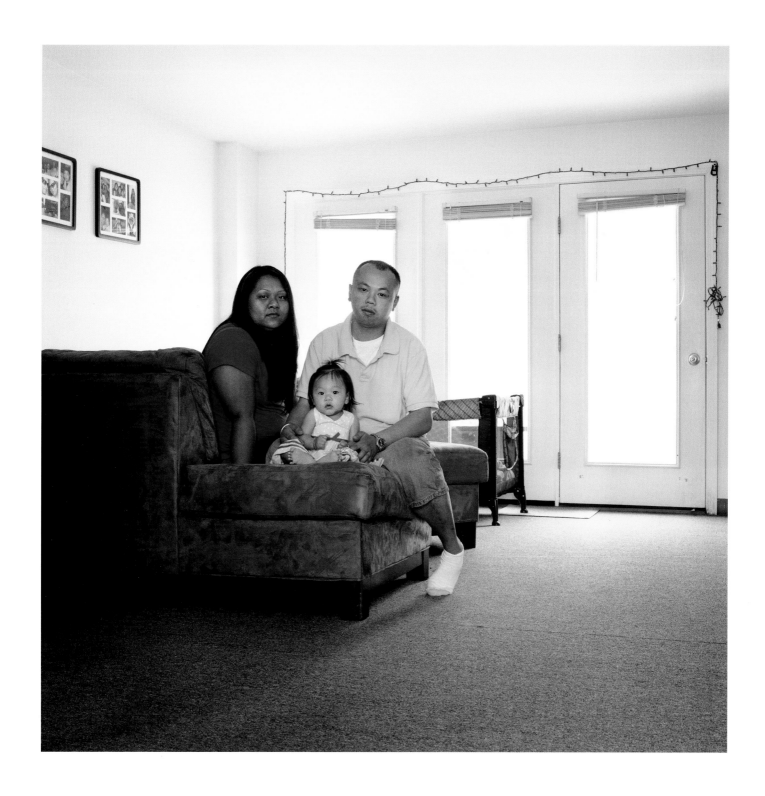

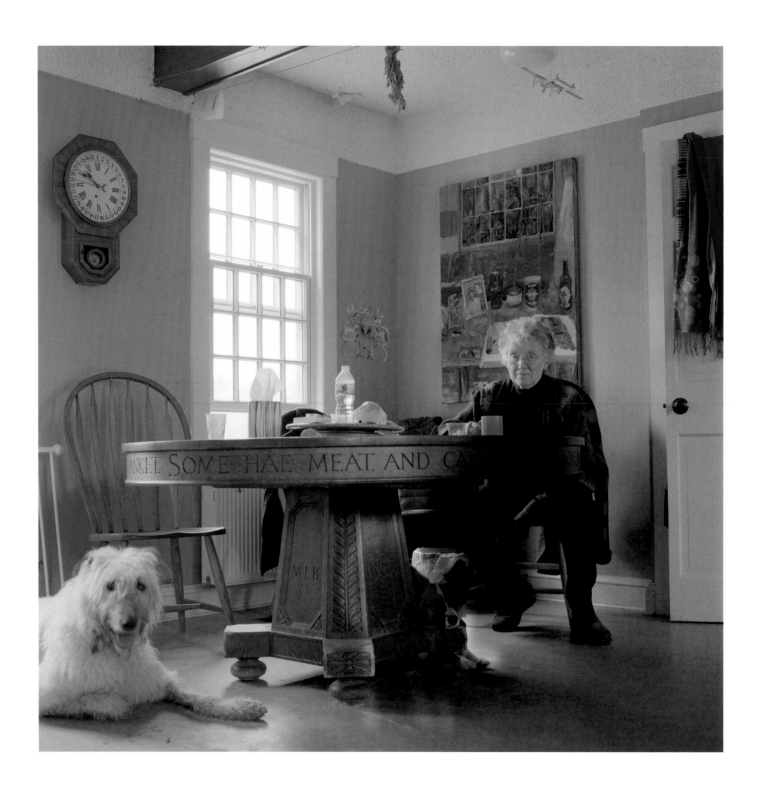

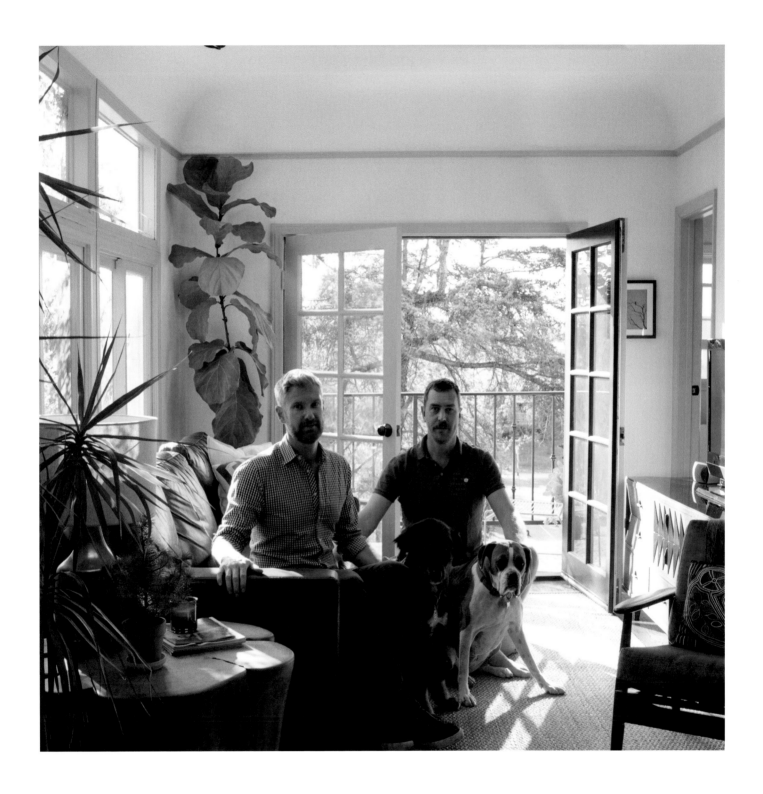

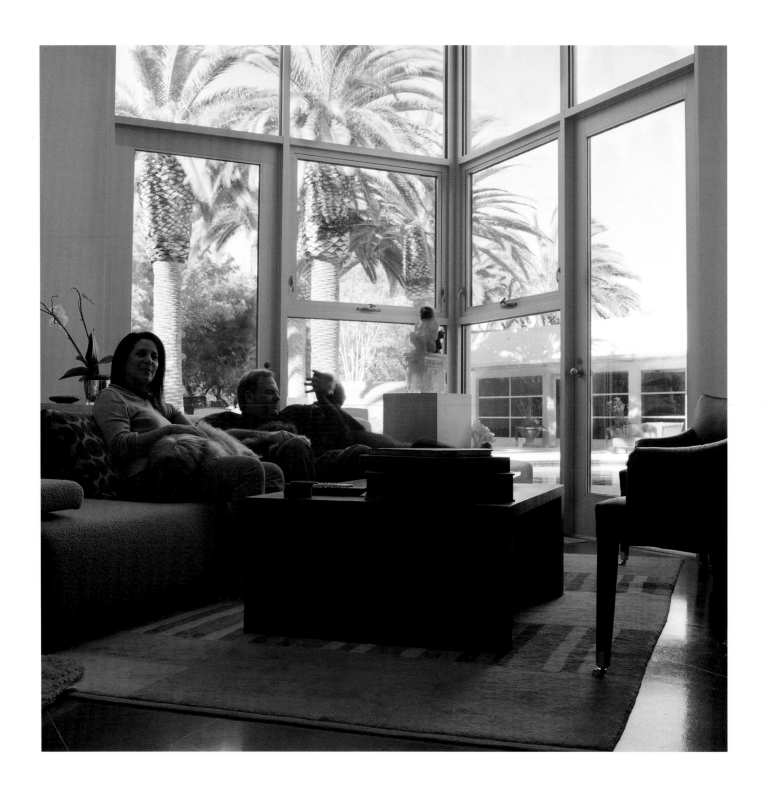

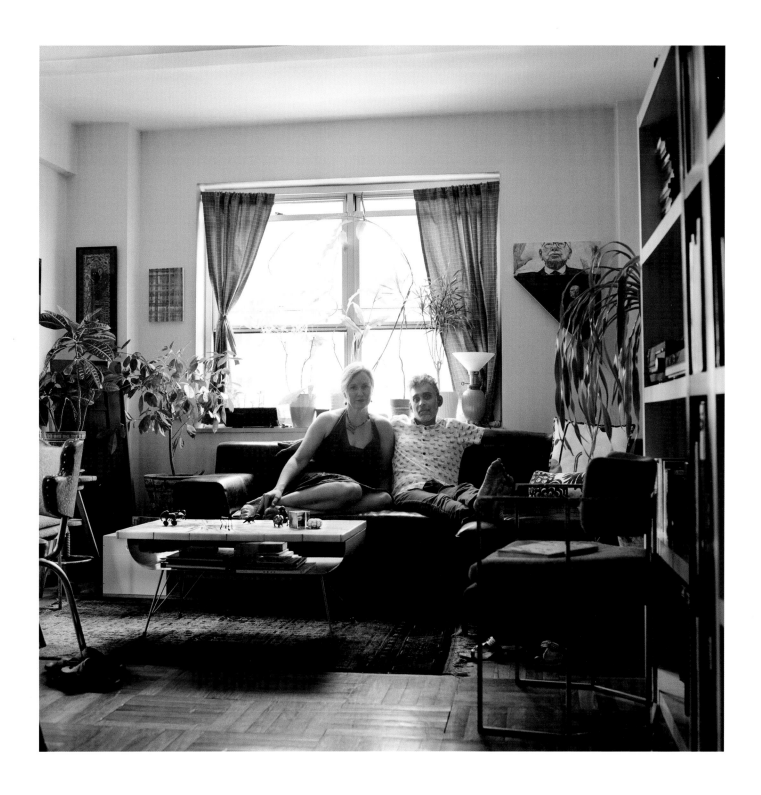

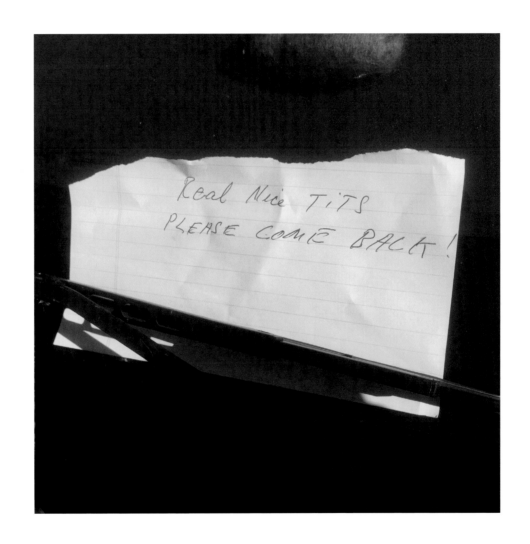

Life in an apartment that is not yours: accidentally making decaf morning coffee; trying to eat the art (plastic apples); spending ten minutes trying to figure out how to use the fancy can opener to open a can of milk for said coffee; giving up. #seattle

I just found out the most venomous snake in North America is lying underneath the patio chair. #mojaverattler #joshuatree

"You know what would be the American dream right now? Nachos and a beer."
—Per

Twelve beds. Ten cities. Nine studio visits. Five flights. Five shoots. Five road trips. Four States. Four lectures. Three conferences. So happy to be home. #maine

Dallas: pouring rain, thunder and lightning. My friend Chris and I head out to grab
a drink and hear some music. We're about go into The Free Man Lounge when a
homeless guy carrying a bag of returnables approaches us. He's wearing a hat that
identifies him as a veteran, so Chris asks him about war. He served in Vietnam. Army.
Infantry. Lucky to be alive. Has PTSD. The government didn't take care of him or his
buddies when they came home. He shows me a bracelet he's been wearing for five,
maybe six, years.

He says he's eaten, but he could use some money for a beer. We each hand him a five.
#texas

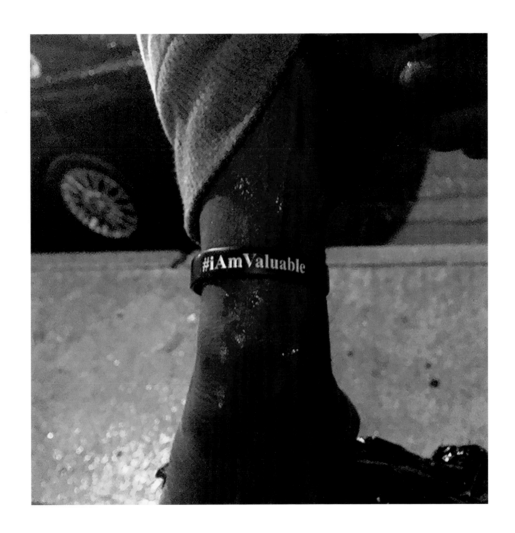

What I think is a major accident driving from Dallas to Houston (hours of standstill traffic) is actually massive flooding. I'm completely unprepared. I manage to find an exit off the highway that isn't under water. I end up parked between two hotels that are fully booked. As I settle in to try and sleep in my car, fear sweeps over me. Fear I haven't felt in the almost five years of doing this project. I have no solutions. I'm out of energy to find them. I'm tired. I want to quit. And I'm alone in the middle of the night in an alley in Corsicana, Texas.

The next morning, I learn that I'd driven straight into the eye of Hurricane Patricia— so fierce, she derailed a freight train just miles away from where I slept. #texas

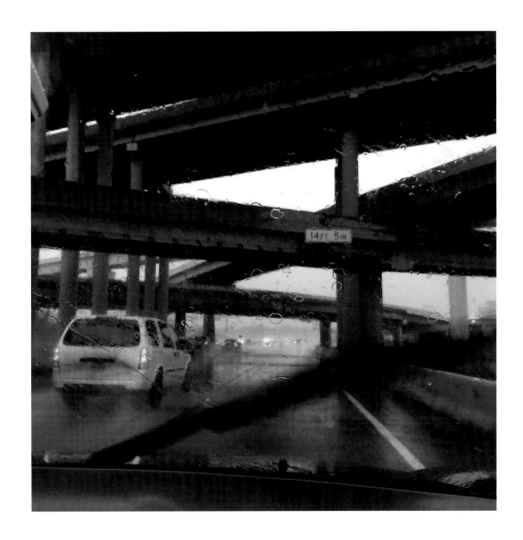

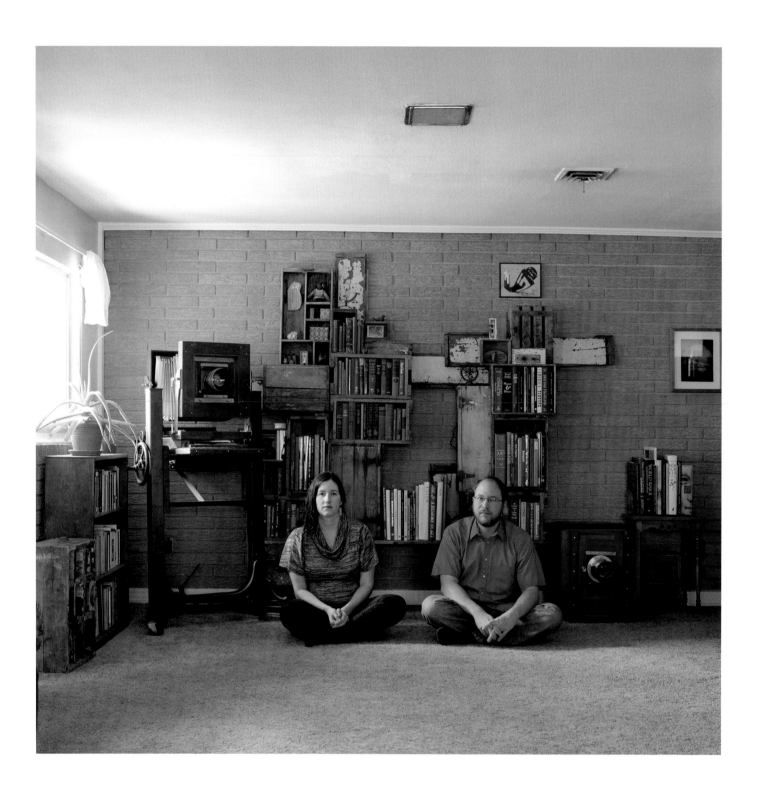

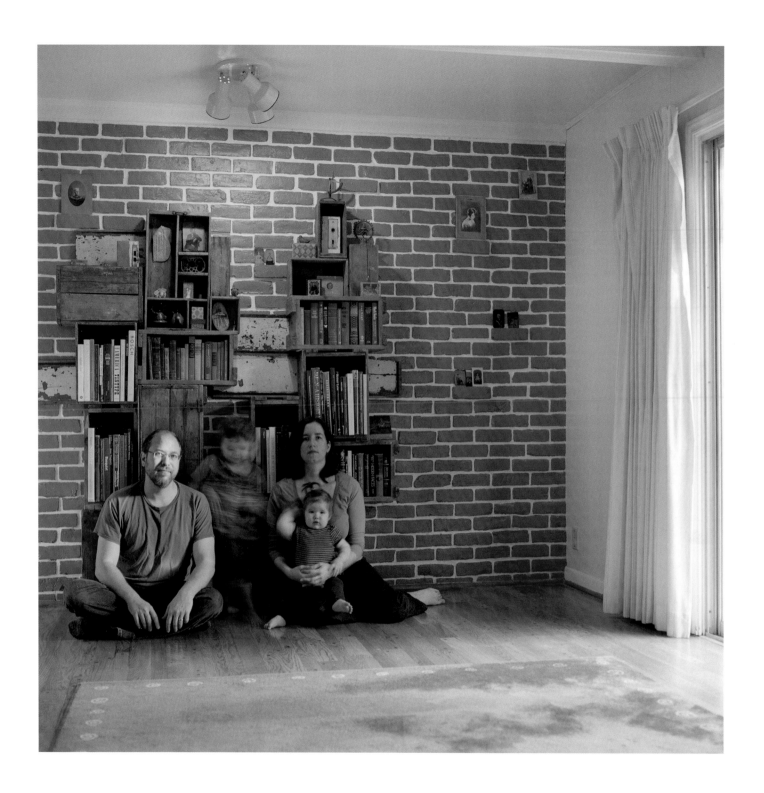

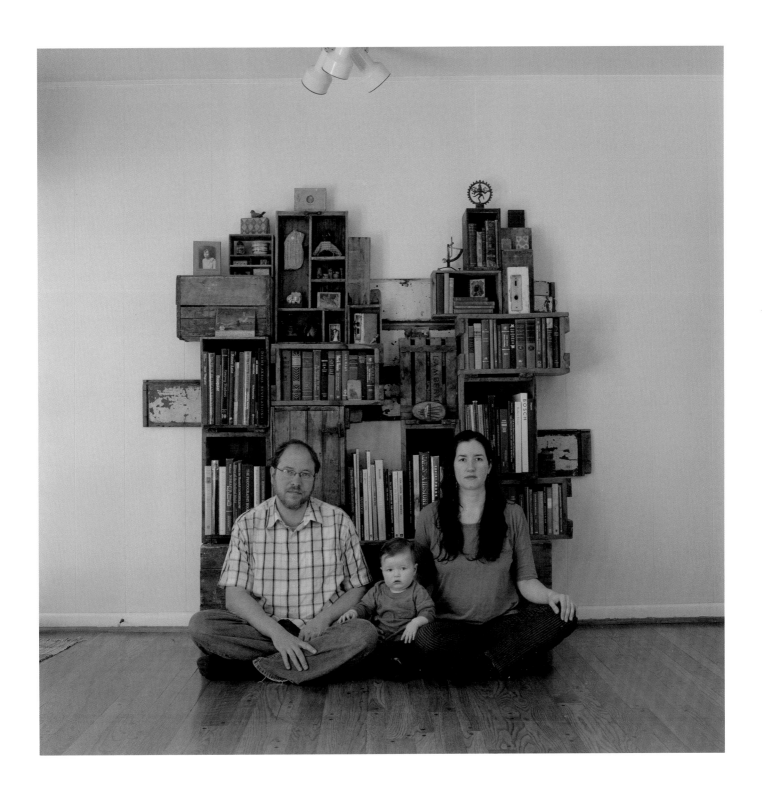

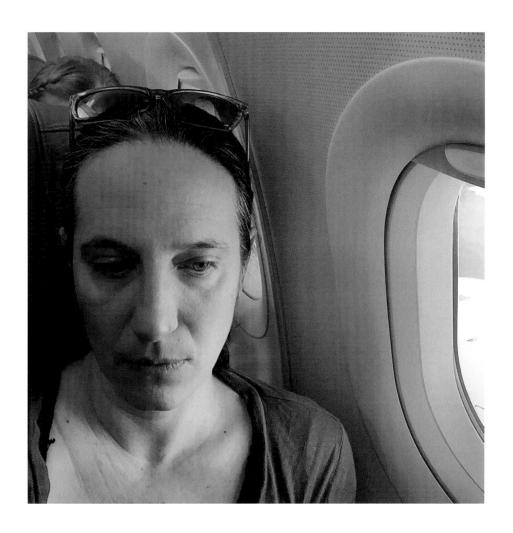

The good news: I made it home. The bad news: I just lost power. #uncle

No, Tanja's artwork says. This is how we actually live, with all of our detritus and compromise. This is the real physical stuff of modern existence behind the artifice of our Facebook facades.

But that is the artistic gamble, and why Tanja's project unnerves some of her viewers. These images will cause profound discomfort for those of us who tiptoe around ideas of class and income. With each captured moment, she speaks that most taboo of words in today's art world: money. She lays bare the imbalance.

Some of Tanja's subjects occupy elegant, clean spaces; others, profoundly middle-class existences. In particular rooms, even the light through the curtain seems to cast a more modest filter.

Some of Tanja's portraits belie a quiet, familiar struggle. It is subtle sometimes—not as subtle at others. This is our home, some of the faces tell us. We don't necessarily love it here. We work. But we aren't always rewarded. We worry about rent and school loans and doctor bills and whether we will take a vacation. We want more (oftentimes, we need more). But we are here.

We do not like to think about artists thinking about money. Artists aren't supposed to be agonizing over the price of a plane ticket or their credit card limit. And real art, we've told ourselves—the kind that hangs in museums—has nothing to do with needing money.

—Jacoba Urist

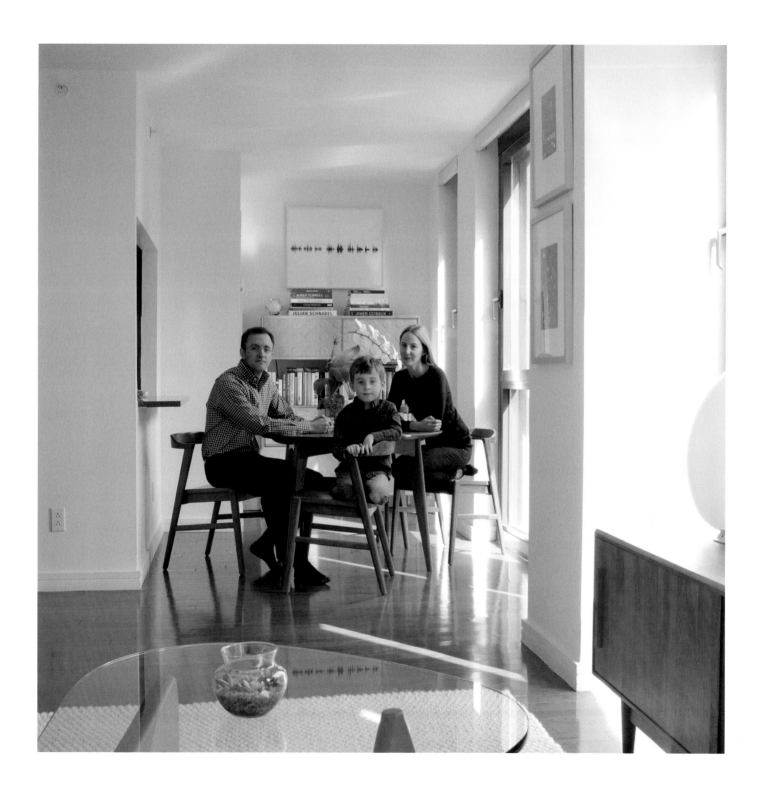

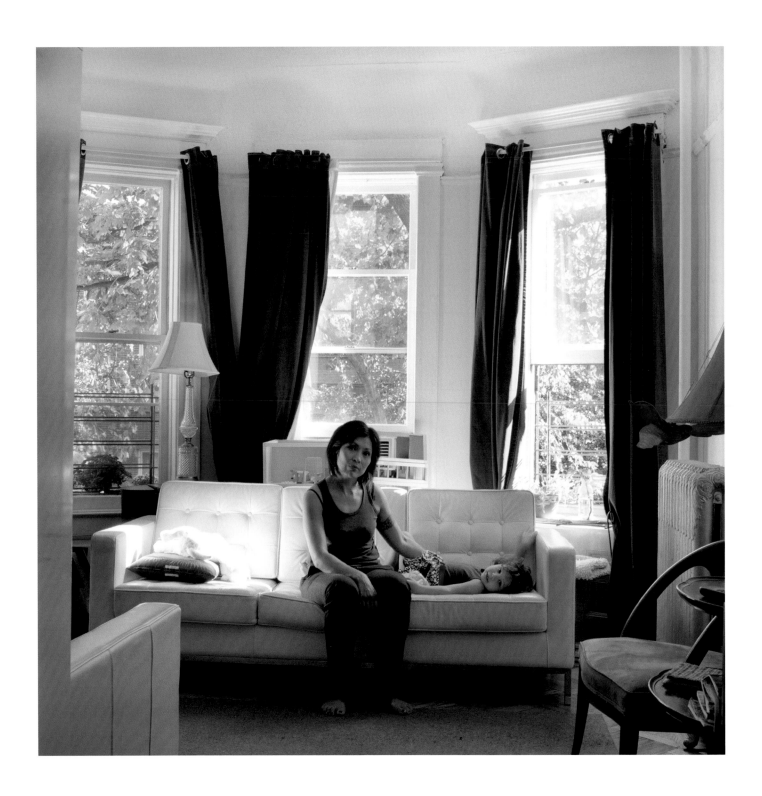

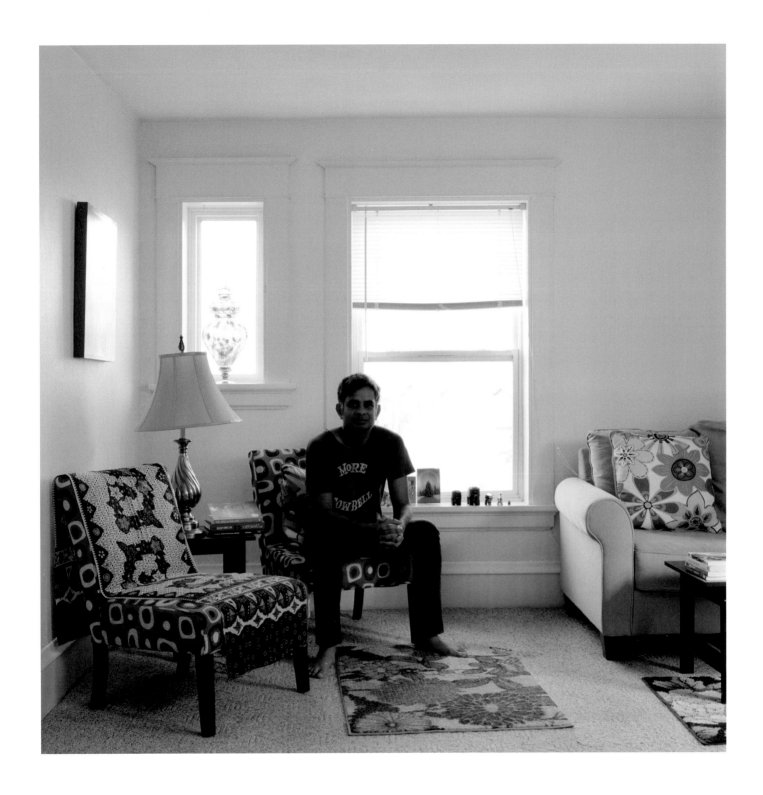

Boiling water, literally boiling—you can see it bubble—seeps from underground hot springs on the Coromandel Peninsula. For two hours on either side of low tide, you can dig a little hole, and hot water will mix with the tidal water. You've got your own little self-made spa!

We case our spot, dig our hole. I make a tripod on a ledge of sand with my purse, start a selfie video, and sit back and relax. A giant wave comes. #newzealand

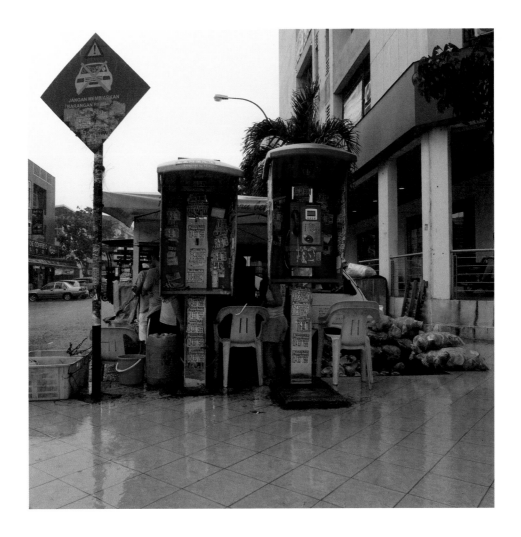

A real friend jumps out of the car to grab you a fresh coconut water during a tropical rainstorm. #malaysia

A walk through Athens with Elena: a chef insists I try his beef tongue and salted baby squid; a mini-biennial in an abandoned school; a visit to Praksis—a nonprofit that serves immigrant, homeless, and drug-addicted people; and Pantelis Melissinos, a poet/sandal maker who makes me a pair of custom sandals—the best thirty euros I have ever spent. #greece

"St. Denis is like the Bronx of Paris." —Mike
#france

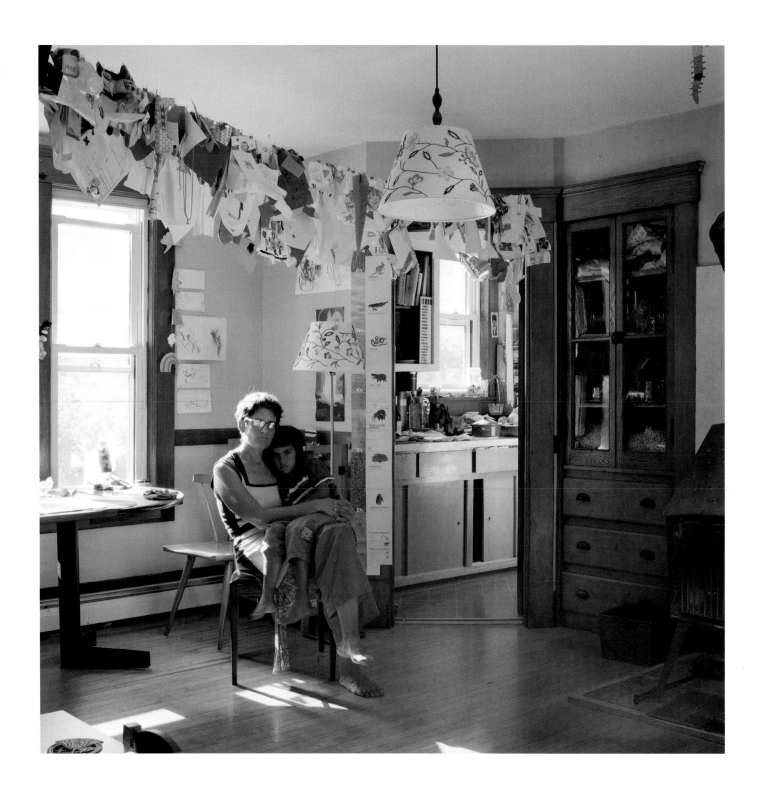

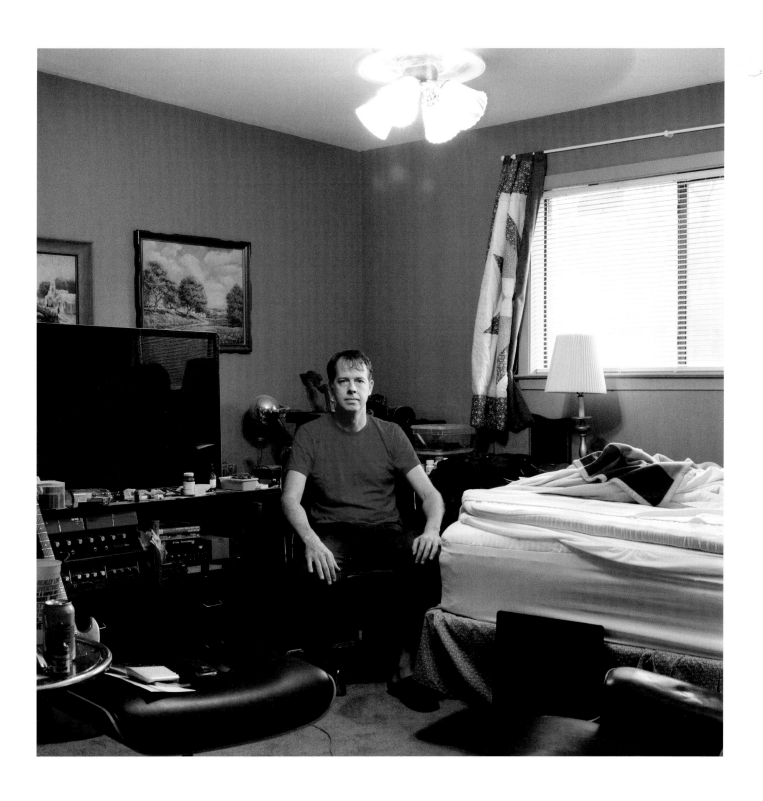

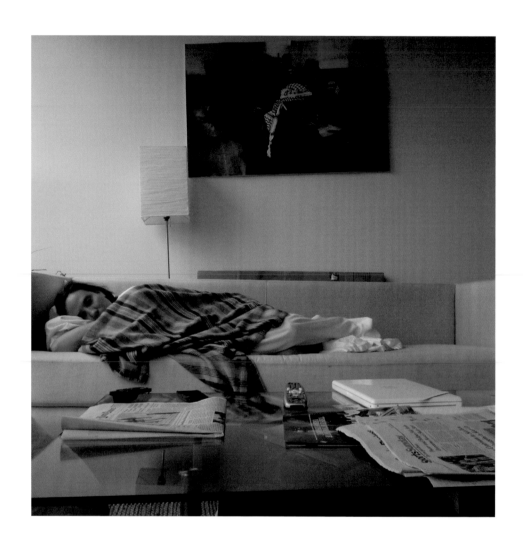

Wakes you
up for the
Sunrise.

I graduated college in 1994. I say graduated, but I never actually got the piece of paper. My "diploma" was a note from the business office asking me to pay my outstanding tuition balance. I still haven't paid it. My salary for teaching this week-long intensive class with @jeffsharlet won't cover my outstanding balance at @hampshirecollege.

When my dad died
unexpectedly... my
best friend (from birth)
had a plane
ticket home
before I even did.

a real friend is
Someone who buys
your drawings
when The Bank
freezes your account

A real friend
offers TO
pay for
your
abortion.

The peanut
butter to my
jelly

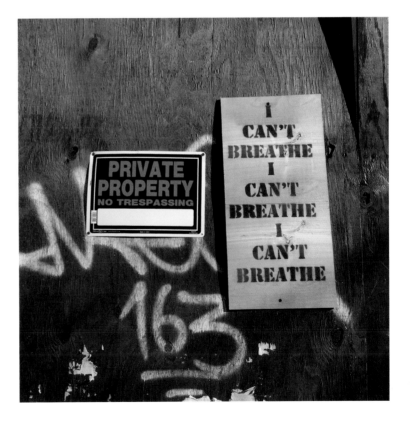

I meet my childhood friends for drinks and dinner at our favorite pub, O'Connell's. Gretchen tells me her husband, Clarence—after eight months of looking for work— was hired as operations manager, then general manager, by a travel-stop gas station chain in North St. Louis. At the interview, when asked, "You know how to fight?" he replied, "I grew up around the corner," and got hired on the spot.

"Good thing our life insurance policy is active," Gretchen jokes. She slips a twenty onto the tab when the bill comes. I slip it back. This goes on for a bit, sliding the money back and forth. It's not my last twenty, or hers, but close enough for both of us. She wins, and tells me to use the cash to get some coffee and gas for the next leg of my trip. #stlouis

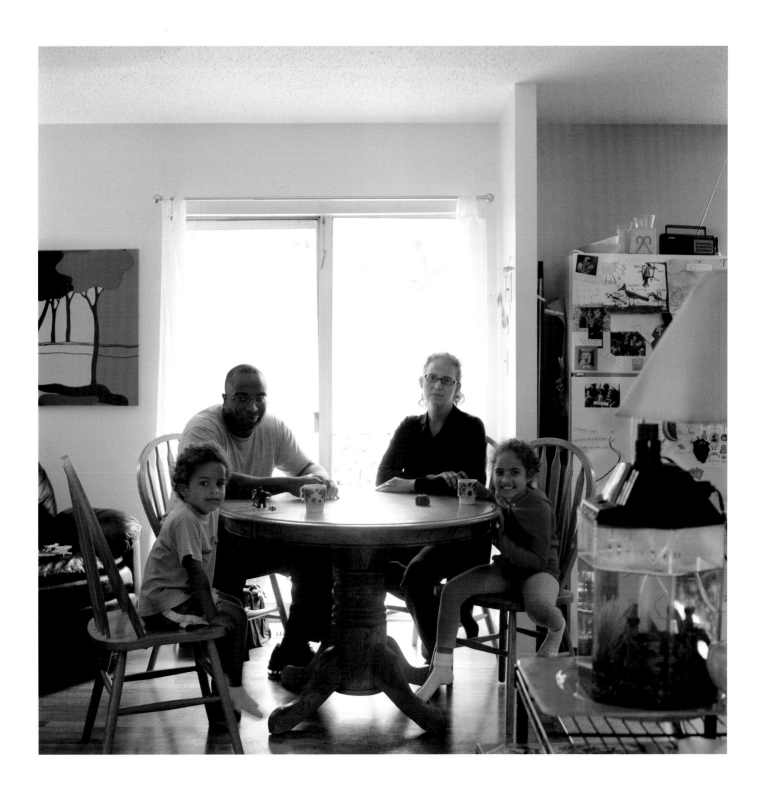

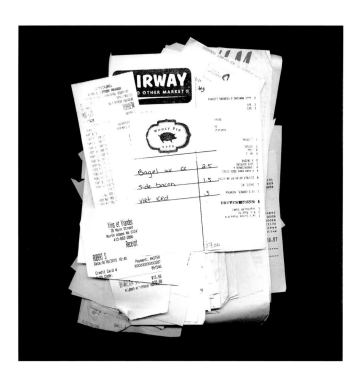

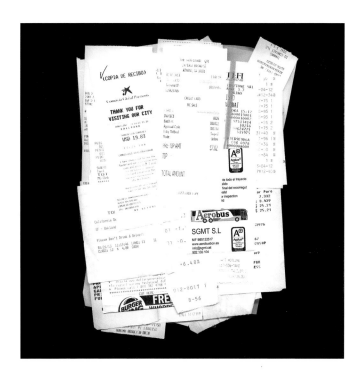

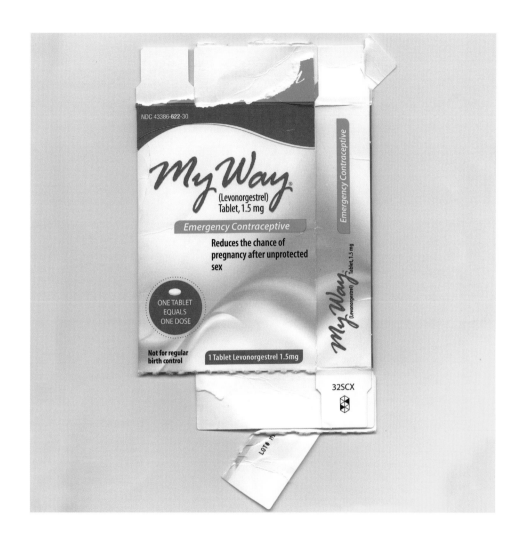

NDC 43386-**622**-30

My Way®

(Levonorgestrel)
Tablet, 1.5 mg

Emergency Contraceptive

**Reduces the chance of
pregnancy after unprotected
sex**

ONE TABLET
EQUALS
ONE DOSE

**Not for regular
birth control**

1 Tablet Levonorgestrel 1.5mg

Emergency Contraceptive

My Way® (Levonorgestrel) Tablet, 1.5 mg

32SCX

LOT #

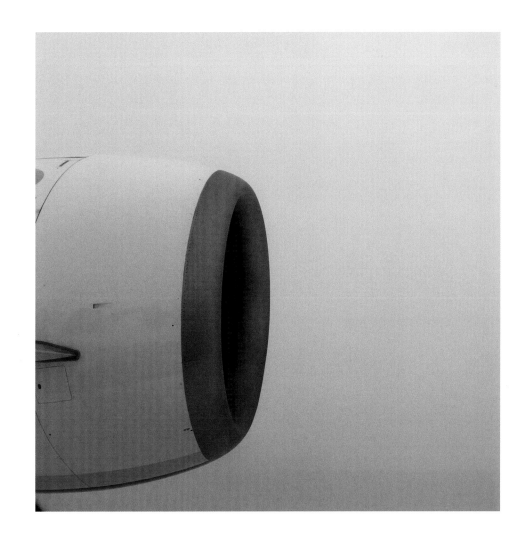

From: Tanja Hollander
Subject: reflections
Date: April 27, 2016 at 6:22:00 PM EDT
To: Robin Greenspun

The unresolved nature of my complicated romance is seeping in as AYRMF comes to a close. I'm trying to figure out if a private life is possible in such a public project. That fine line between personal and public, which I have analyzed from a distance, I now find myself at the center of. There's no easy answer or black and white formula. Much like the work, our relationship evolves, recedes, evolves again.

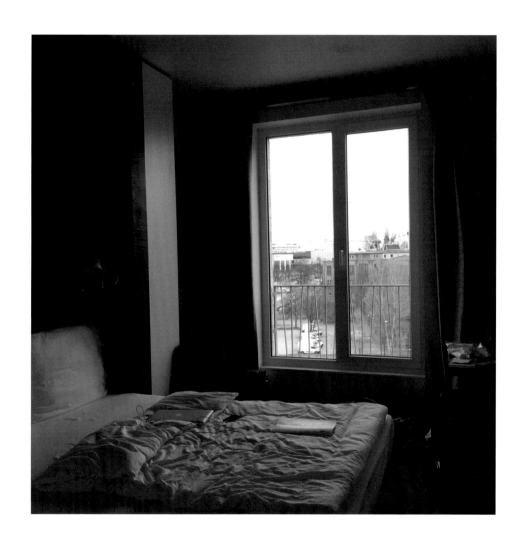

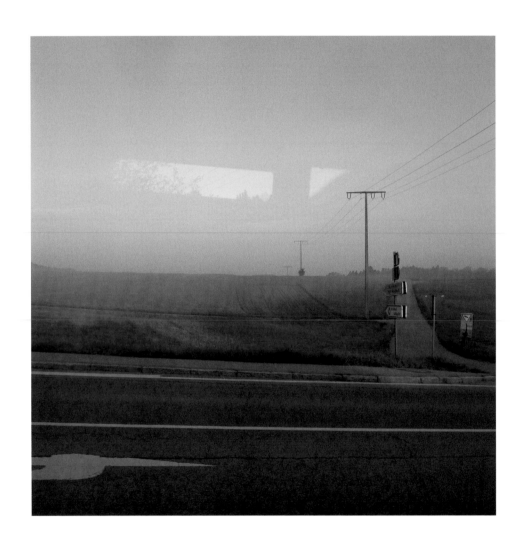

Pounds, euros, dollars. Keys that are temporarily mine. Flowers, no candles. #london

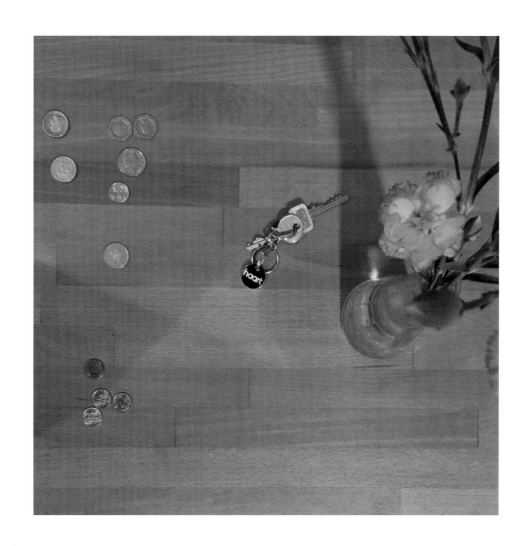

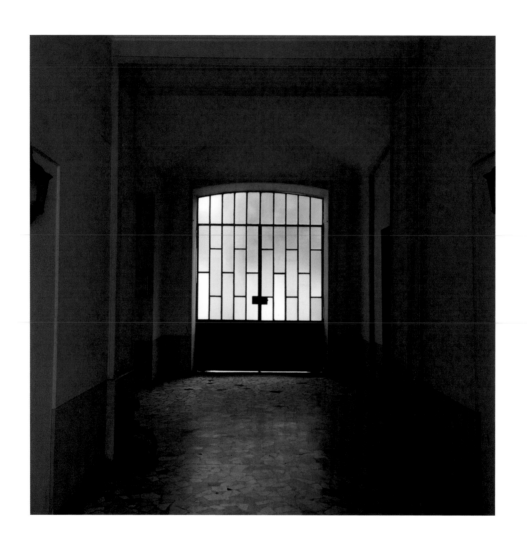

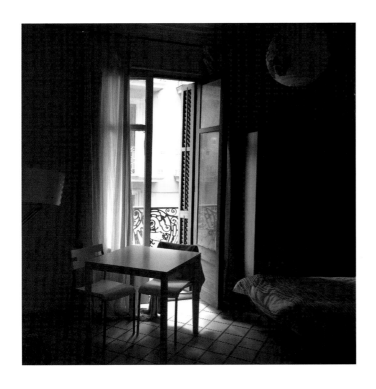

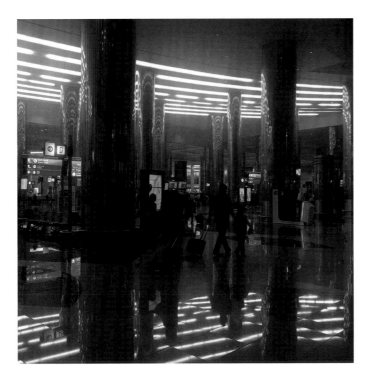

When I was in colonial Williamsburg driving to Raleigh, North Carolina, I accidentally drove onto a ferry. I went into a full-on panic—in the rearview mirror the deck hands were closing the gates. I had no idea why I was on the boat, where the boat was going, or how much it cost. As it took off, I became more and more distraught.

I calmed myself down. Surprise boat ride! I love boats, what's the big deal? If I was lost, I'd find my way once I got off the boat. If it cost money, I'd figure out how to pay.

The psychological effects of being lost are really interesting. It's hard to convince yourself it's not the end of the world—even if intellectually you know you will find your way, but emotionally it feels like the ground is collapsing below you. The feeling is amplified because I'm alone in an unknown place, headed across the country for an unknown amount of time, with an incredibly loose itinerary. Maybe the fear of the unknown seems more extreme when your entire life lacks stability?

That one minor blip has come to symbolize a much larger story about this project. I've had to trust myself and the ups and downs of travel; to trust in pretty much everything I do and everyone I interact with. I have to trust that my car won't break down in the middle of nowhere, that my film will come out, that I remembered to charge my batteries, that my phone won't die . . . on and on and on. I didn't realize how much I depended on things falling into place until I found myself thinking, "Why am I on this boat?"

R. teaches me about witches, about the people who have lived and died on the Grand Canal for centuries, and how she'd rather collect shells than listen to her parents argue. #dublin

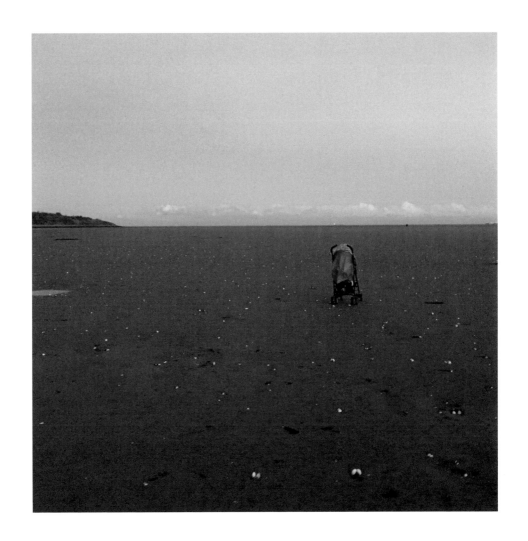

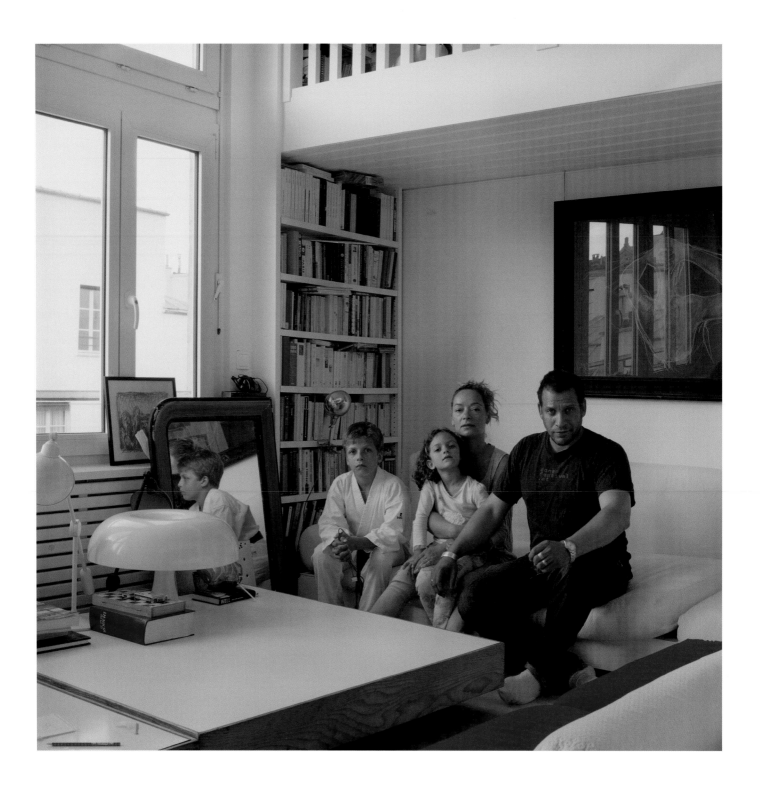

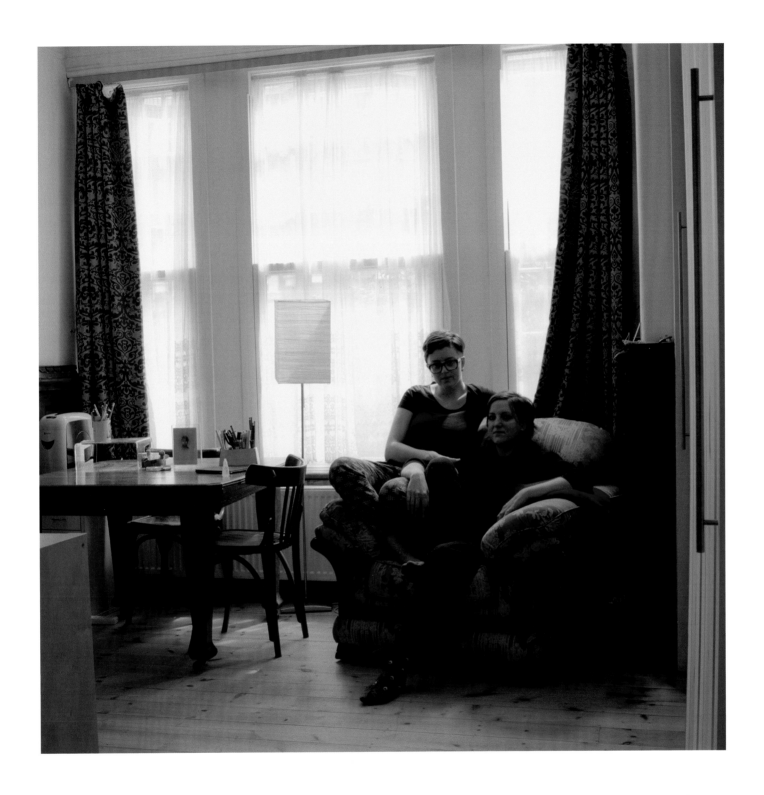

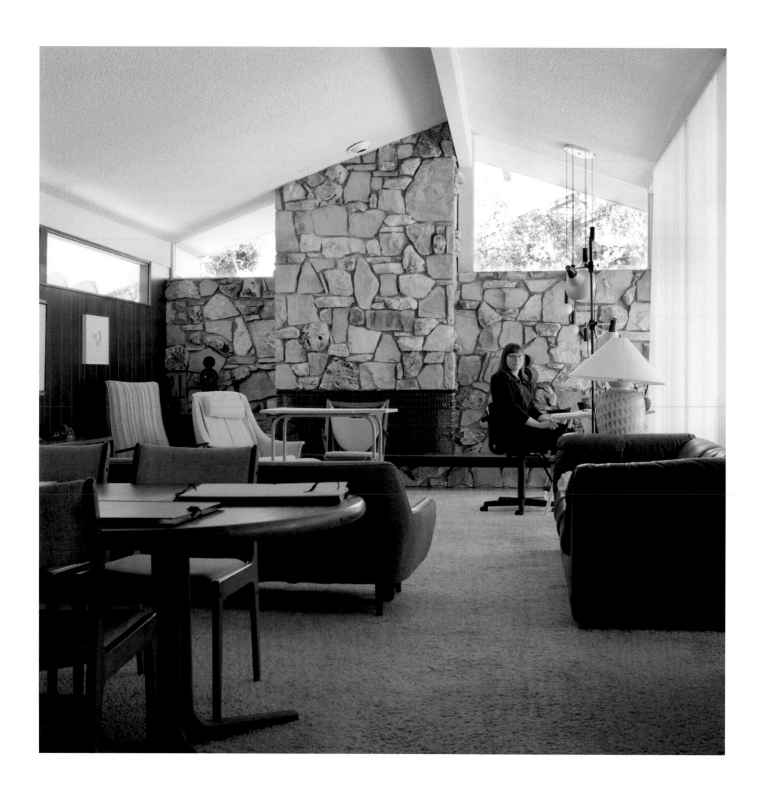

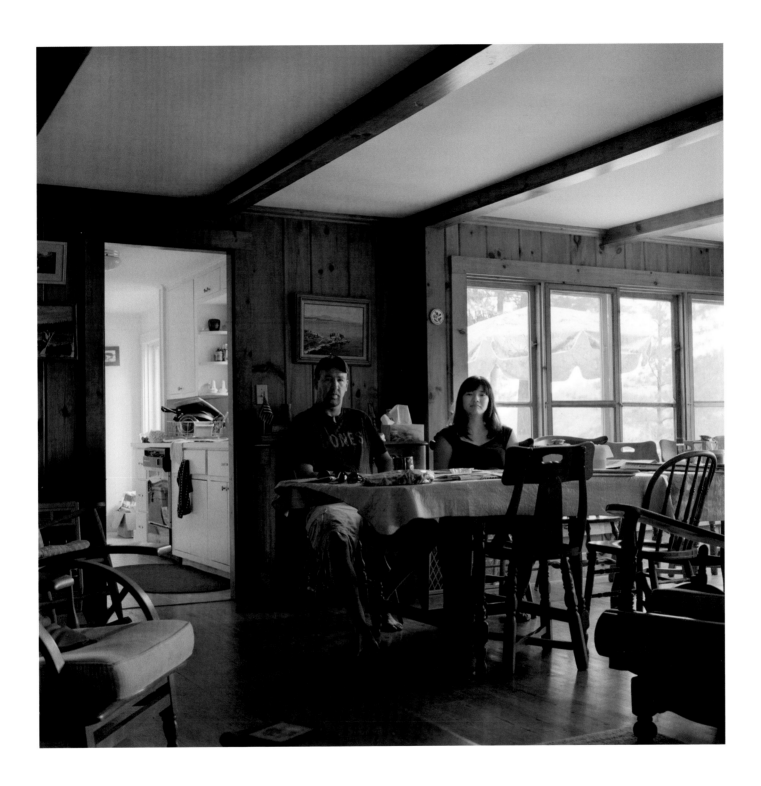

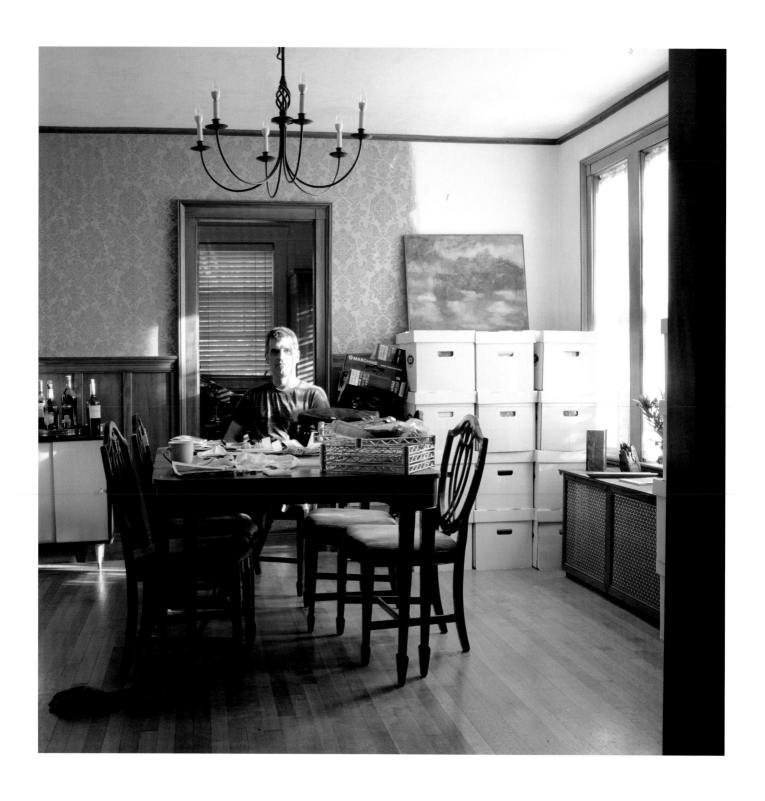

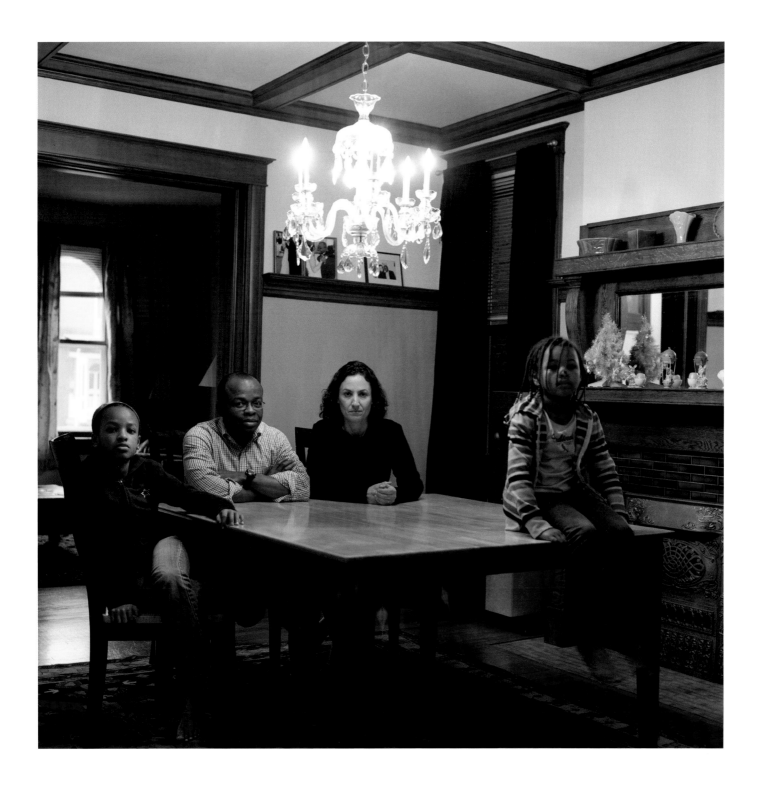

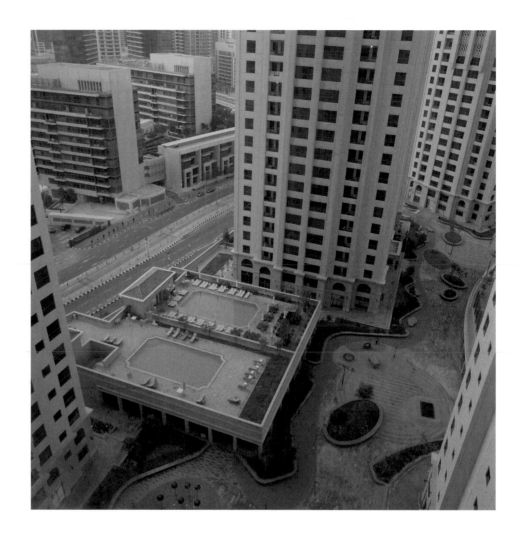

My impression after eight hours: Vegas meets South Beach, minus the sex and booze.
#dubai

I just locked myself out of my own opening at the German-American Institute in Freiburg and can't figure out how to get back in. #willtheynoticeimgone #germany

I've been on Koufonissi for a couple of days when Maro
calls from her new home in Sounio, a summer camp for
kids turned into a camp for refugees. She calls between
meetings with NGOs, military officials, translators, and
volunteers to make sure I've made my ferry to the island.

Before I leave Athens, Petros finds a way to leave me
the keys to his apartment; he's in Brussels meeting with
the European Parliament. Katerina orders me sushi in
between what she calls "refugee-ing"—a nonstop 24-hour-
a-day mission since the three of them—Maro in Lesvos
and Petros and Katerina at the port of Piraeus—found
themselves with 10,000 meals a day to prepare.

Last night, the temperature dropped dramatically,
winds started blowing. This morning I wake up to a
Mediterranean unknown to me. No more hot quiet days,
no more sea that is crystal clear in perfect shades of light
yellow, yellow. Light green, green. Light blue, deep blue.
No more rippled sand that massages the exhaustion out
of my toes.

Today the wind blows fierce, it doesn't howl, but it's angry
and knocks you down. "From the North," Ageliki tells me.
Like the Santa Ana winds in California. Or devil winds as
they are sometimes called.

I can see the water from my porch, a swirl of yellow blue
green covered in white caps. No more perfect gradations.
Not going to the beach today, I imagine.

Imagine. Imagine being on a boat clinging to your children
in these winds in that sea. It makes me remember I came
to this little island with no lights or Wi-Fi to write one
story and yet, another one is forming.

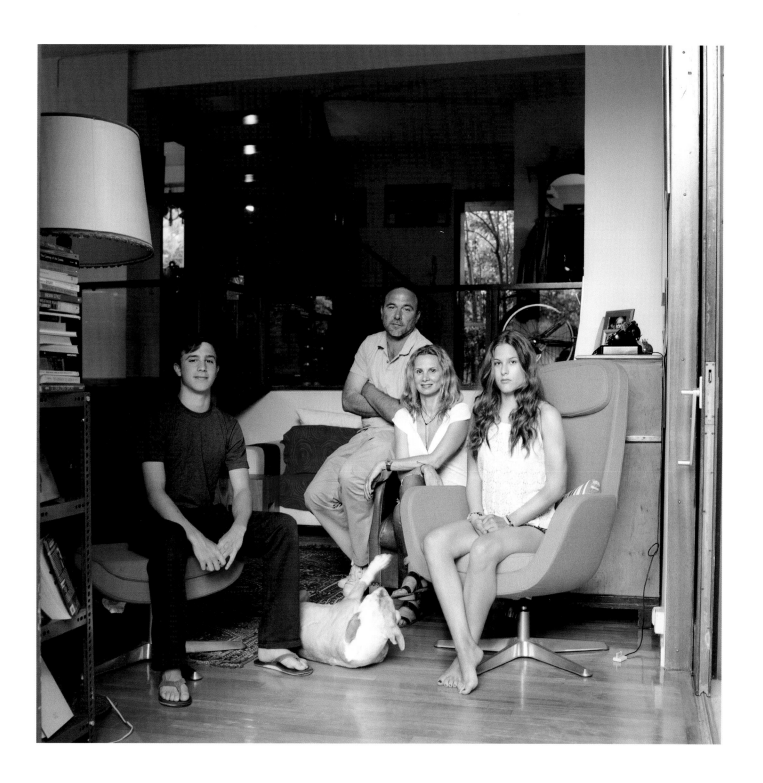



Detained by Head of Security for "all of Greece." Interrogated twice, body searched,
all my cameras and luggage confiscated and checked. I'm escorted to the bathroom,
and then to the plane, which I'm allowed to board with one phone, ten euros,
and my passport. But we reach a compromise—the purser will carry my Hasselblad.

We land in Tel Aviv. My luggage shows up in two cardboard boxes.
#grandfinale #israel

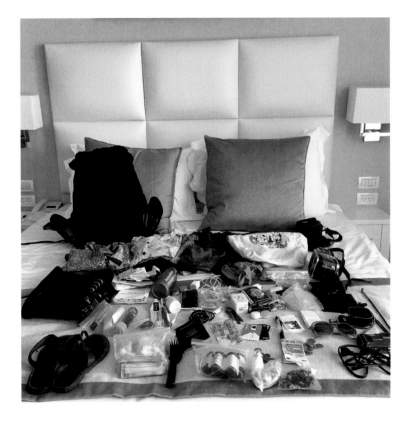

After the November 13, 2015, Paris attacks, Sarah told us we should stay for three days.
"Why?" I asked. "Three days of mourning," she said.

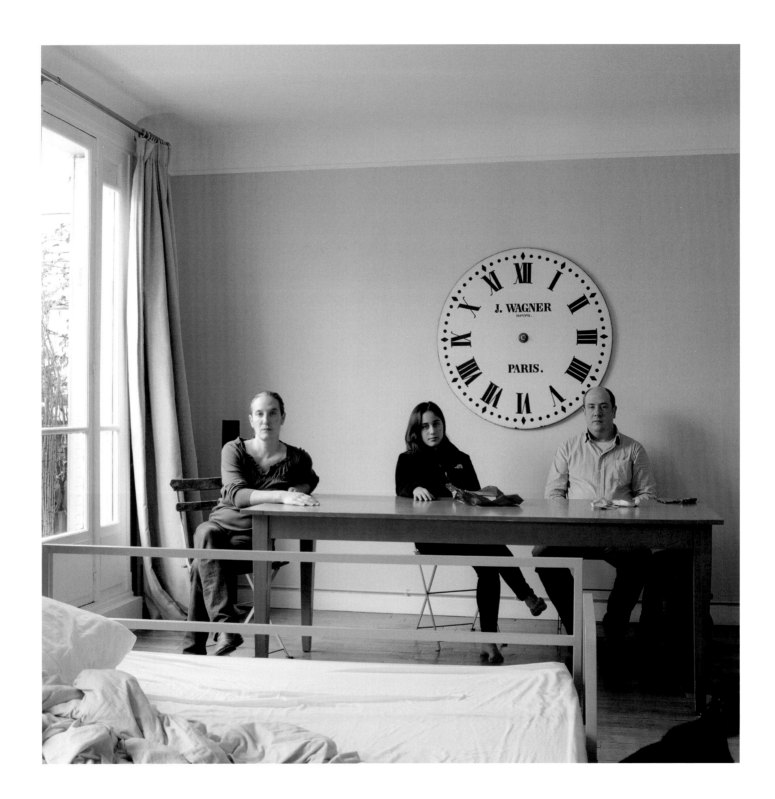

METROPOLITAN POLICE APPEAL FOR ASSISTANCE

The Metropolitan Police Service is appealing for information in relation to the recent attack in:

Paris
Friday 13th November 2015

This message is for all passengers including those transiting:

Did you witness the attack?

Do you have video footage, mobile phone footage or photographs from the scene?

Please make yourself known to a Police or Border Force Officer.

You can also contact the free, confidential Anti Terrorism Hotline on 0800 789 321

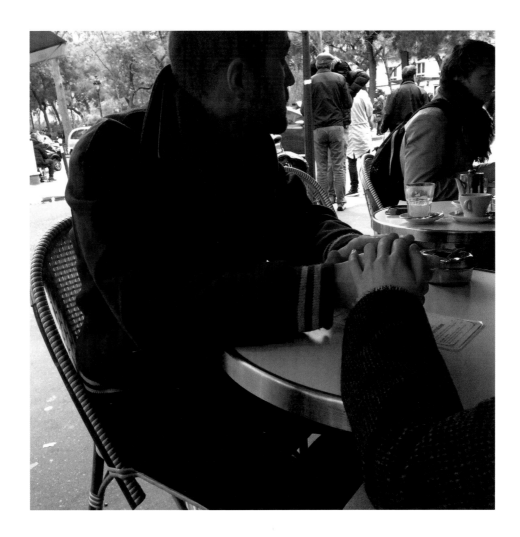

Across the street from the press camp, flower vigil, and Bataclan. I wouldn't usually post an image like this. Strangers in a cafe. @jeffsharlet says there is no usual today.

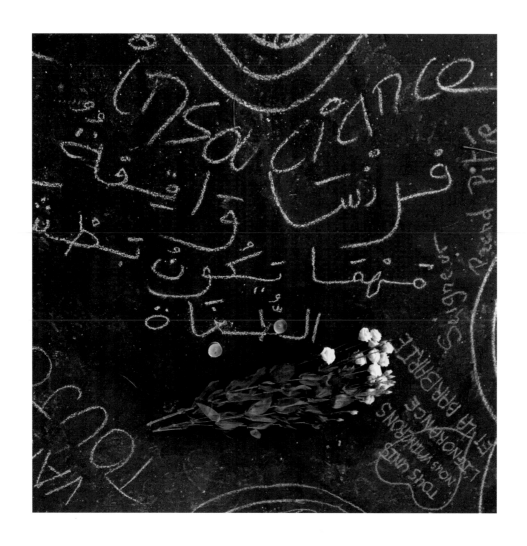

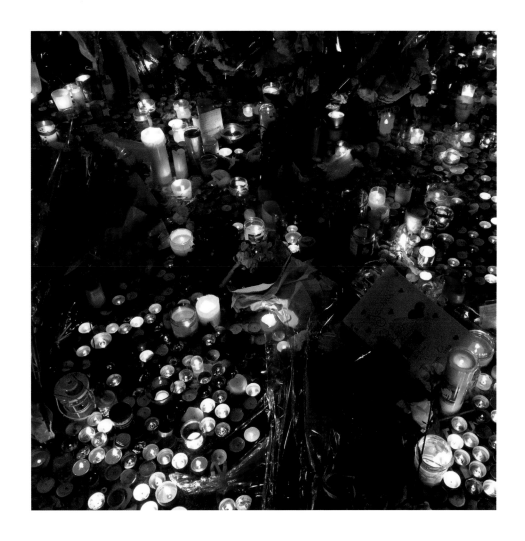

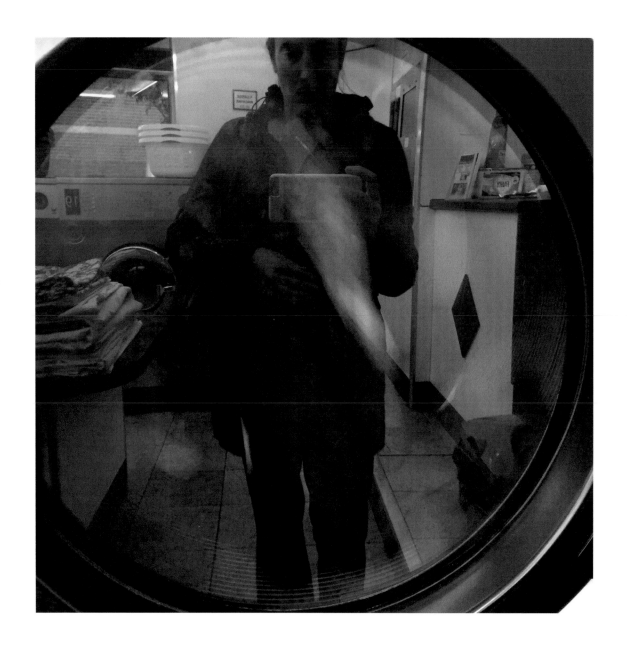

Paris to London. At King's Cross Station an official gives me
a flier—"Did you witness the attack?"

Luna and Ludy are the friends I need right now—they make me
dinner, give me a glass of wine, and then run me a bubble bath.
Luna sets up a battery-operated night light that shines the Milky
Way over the tub.

The next day, I need to leave the house. To do something. It's
raining hard. I can't bring myself to get on the Tube and go to
a museum. So I do laundry. I wash the clothes and walk half a
block to the laundromat to dry them. It's a small place, locksmith
instead of a front desk, maybe six dryers. The last one is empty,
next to the back desk. I try and put pounds in the slot, but the
slot is sealed.

A man shows me the vending machine that runs the washers,
puts in my pounds, and goes back to folding clothes.

I stood there watching the clothes spin. Silence between us.
A TV in the background.

Years ago, while photographing an archaeological site in Italy, I came upon a corridor: it was pitch black, except for occasional holes in the ceiling. Single rays of sun created bright blobs on the dirt floor. My immediate reaction was, "I want these." As I composed each shot, I was constructing each blob's cage. They were mine, all mine.

Since then, whenever I travel and witness something that moves me, I get this acquisitive urge. I lift my camera and I pledge allegiance to the language of photography: I "capture," "take," "grab." And then I own.

At first glance, my experience might be a tiny window into comprehending Tanja's mammoth six-year project, *Are you really my friend?* Tanja has amassed an international bounty; she has shot obsessively, deliberately, with a voracious appetite. Nothing escapes her hungry eye.

But that would be a superficial, even contradictory reading of AYRMF. Tanja's goal was not to take or capture, and her collected treasures have little to do with ownership.

When Tanja began the project, it was a challenge. But it soon became a promise, not just to herself, but to more than six hundred "friends," whether they were mere acquaintances or cherished comrades. The promise was this: "I will come to you, wherever you live, in whatever weather or circumstance, and I will photograph you."

Each airplane flight, each text string, each saved piece of ephemera was part of that promise kept. As soon as the promise was carried out, another one was given: "Our friendship will continue."

The culmination of *Are you really my friend?* is the opposite of experience captured. Instead, it is experience released.

—Wendy Richmond

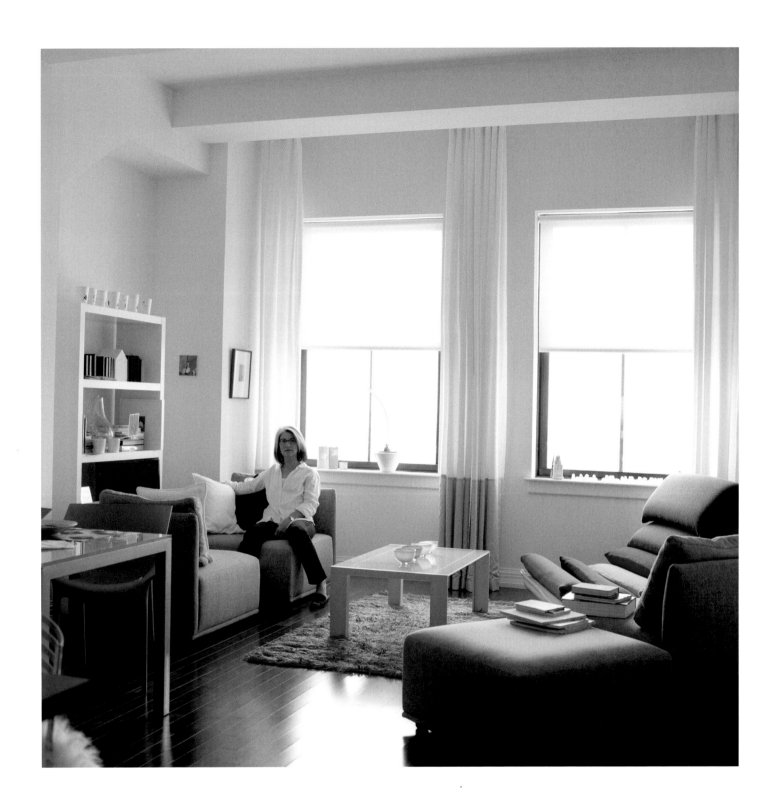

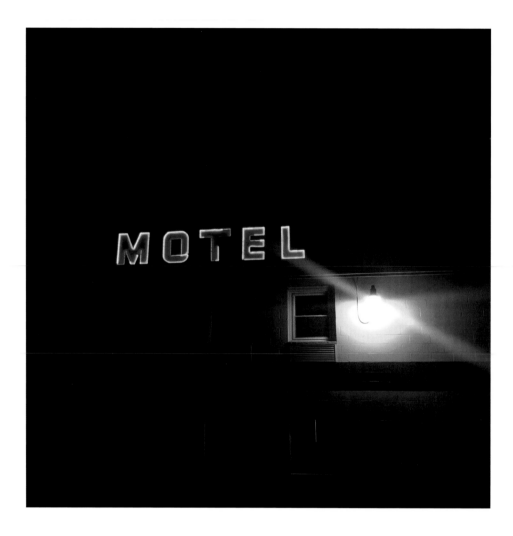

I can't believe it took me seventeen states, eighty cities, and two hundred homes to have the genius idea to buy a GPS. #areyoureallymyfriend

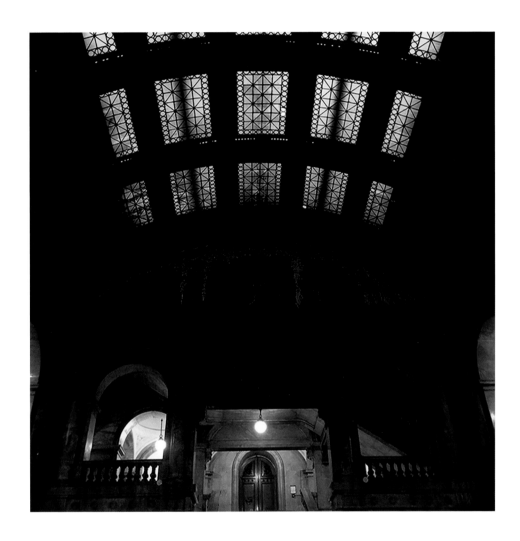

…shelves and shelves of city blueprints, hand-bound leather books with census data in cursive writing, and boxes of crime-scene evidence. Quinn pulls out an 8 x 10 black and white negative, holding it up to a light, three of us gather around—a murder? #nycarchives

Eight year old Carter teaches me about the color red by putting together an entire outfit at a thrift store in Salt Lake City. #utah

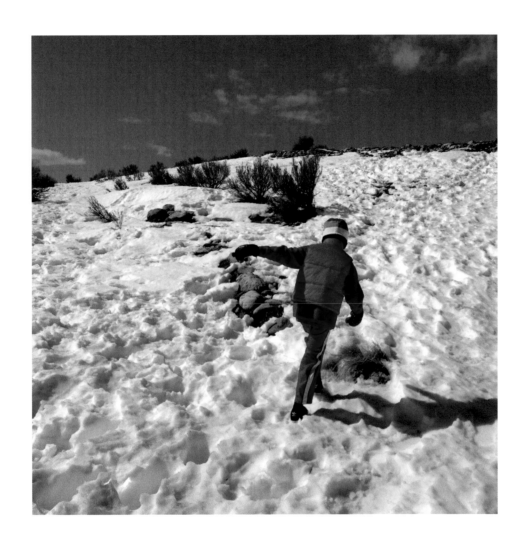

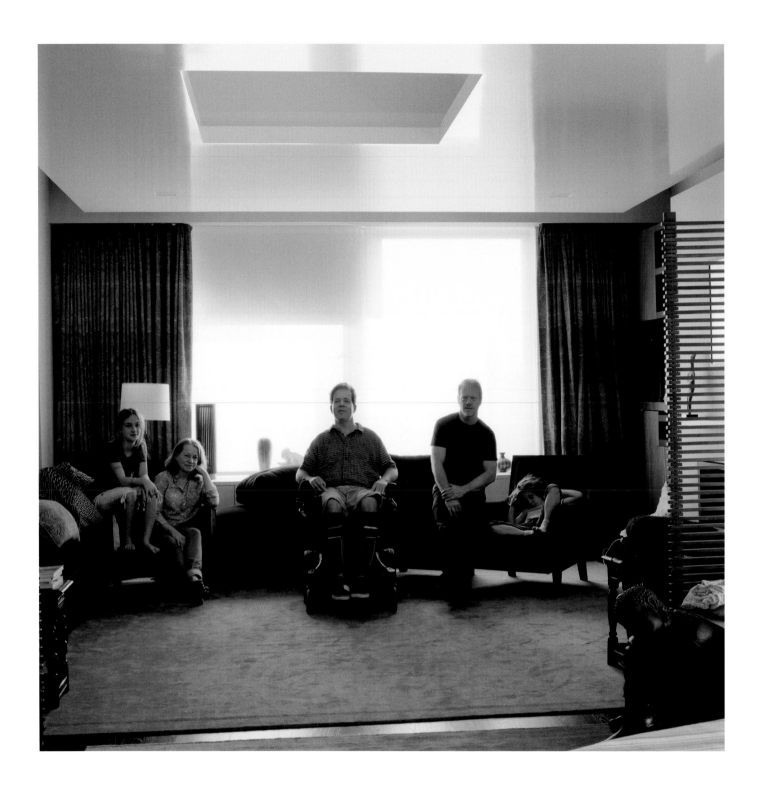

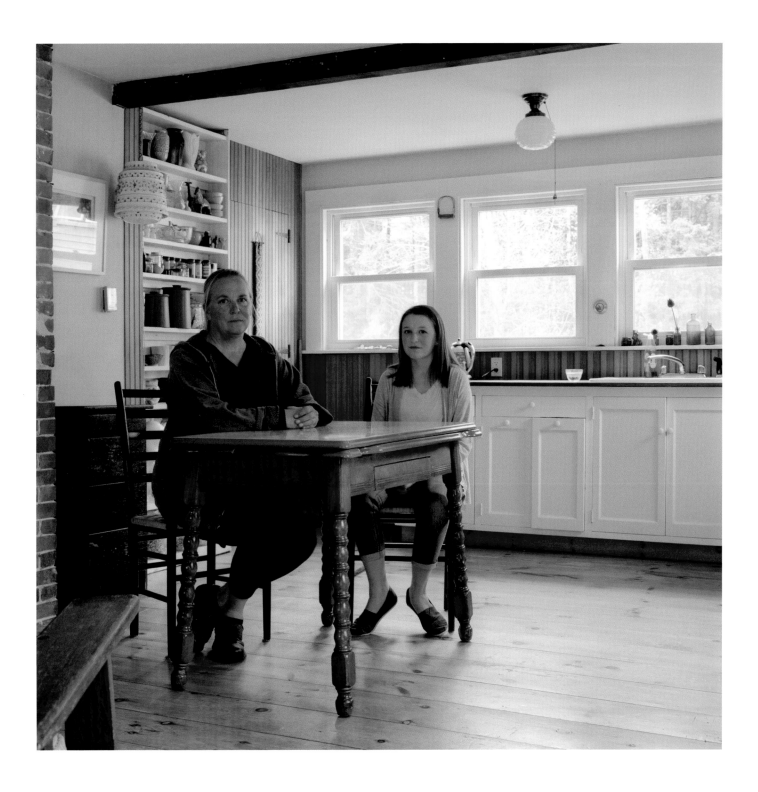

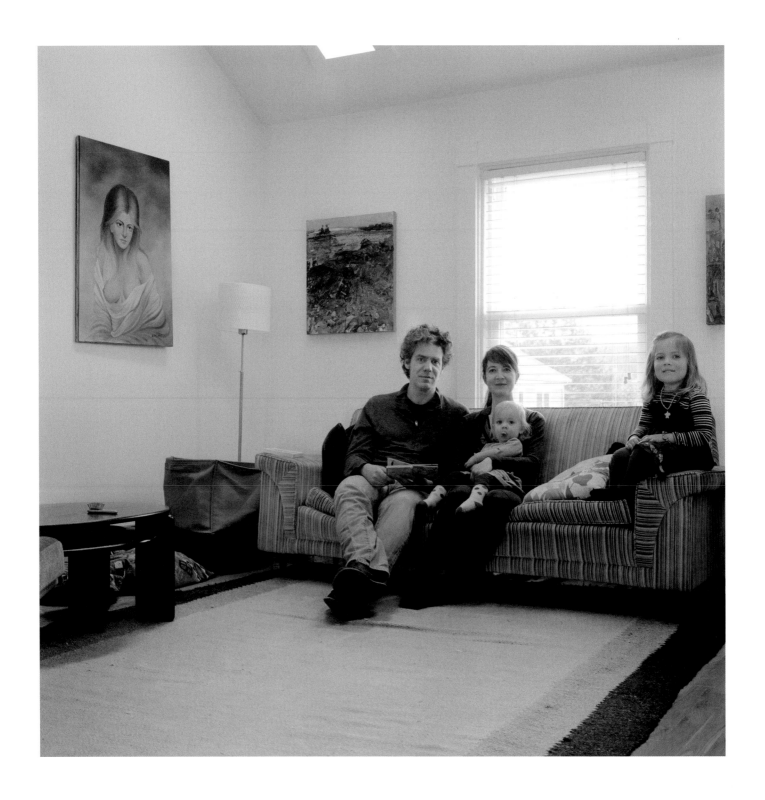

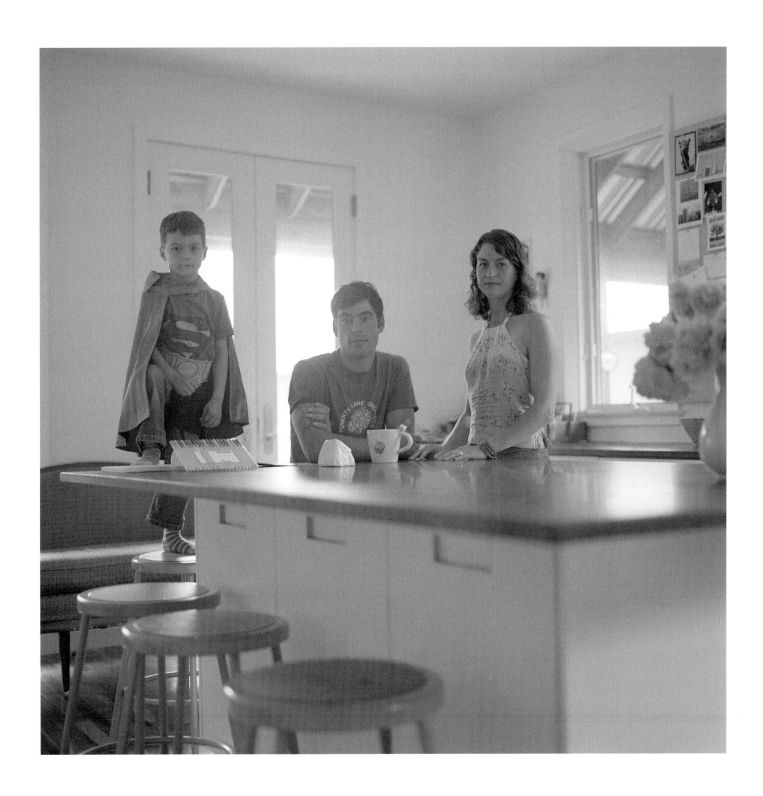

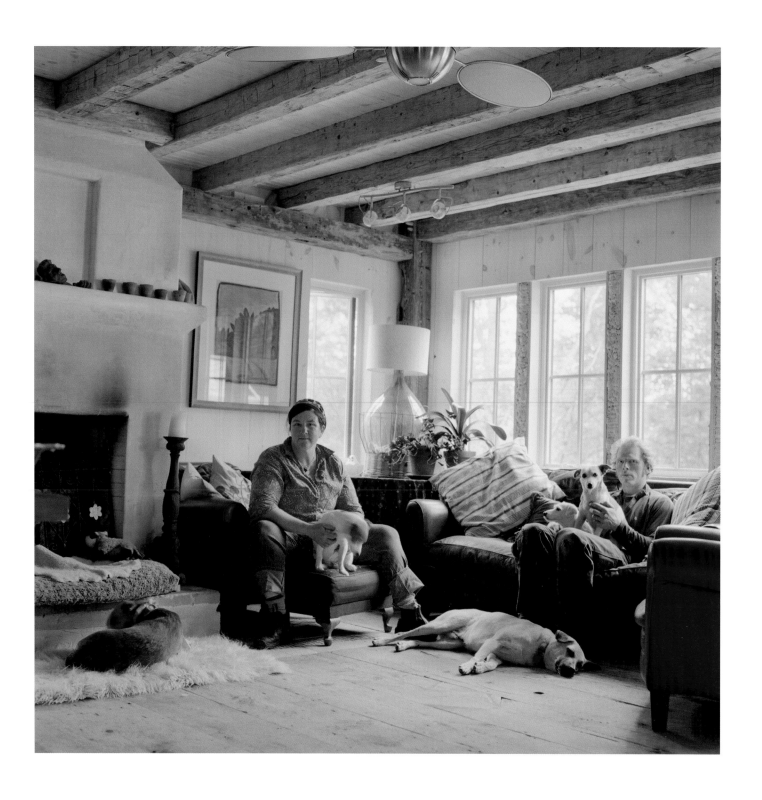

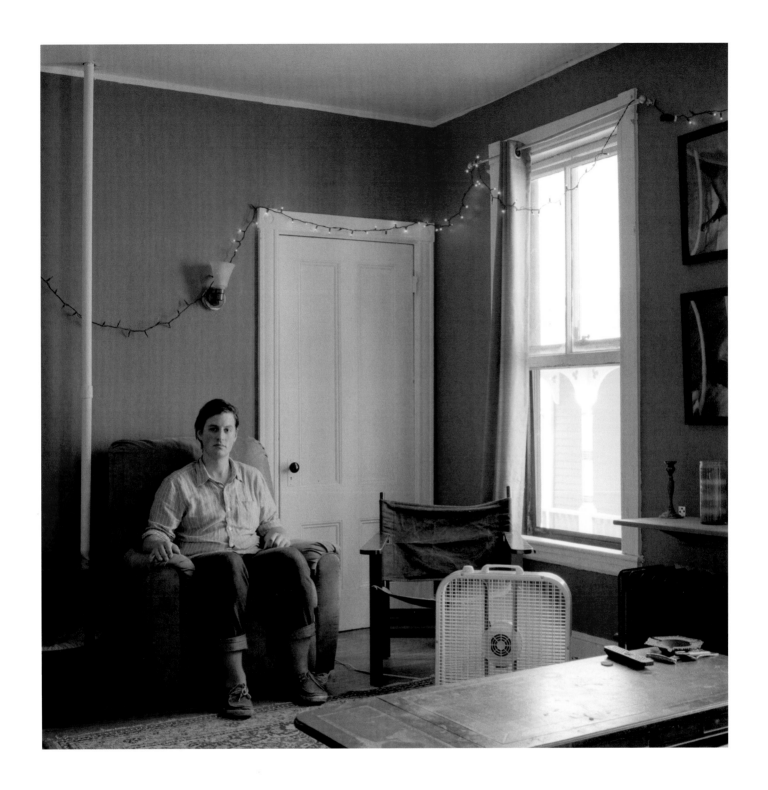

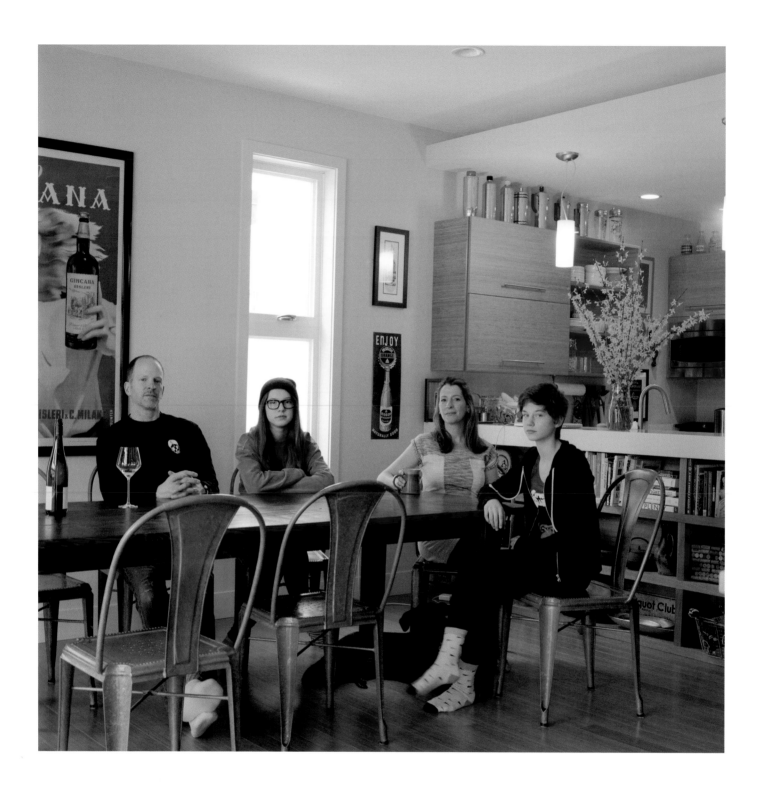

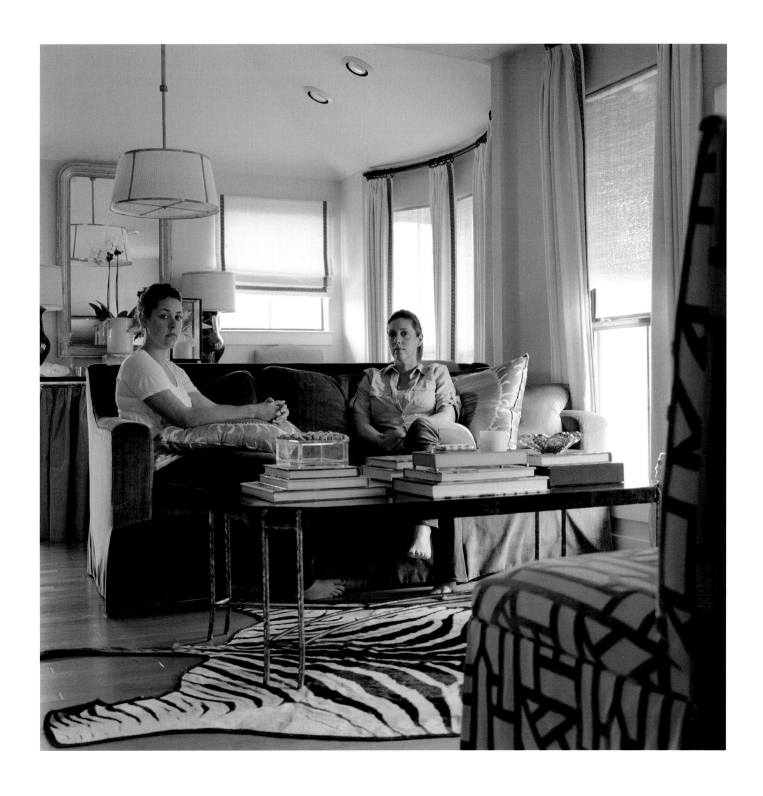

A friend is a person that can always count on you and never stop being your firend even if they are very growy up they always depend on you for good things.

Someone who will Always Be there

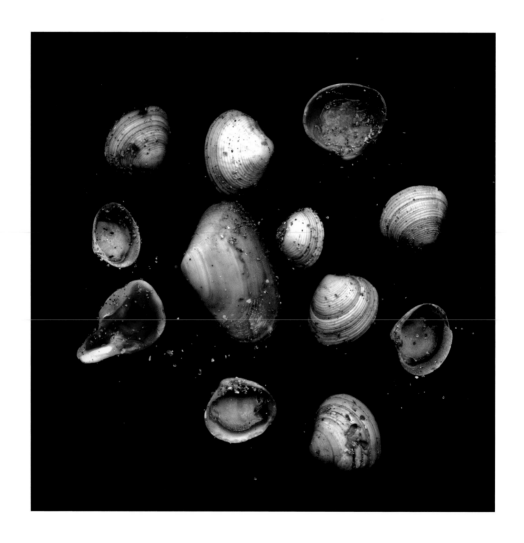

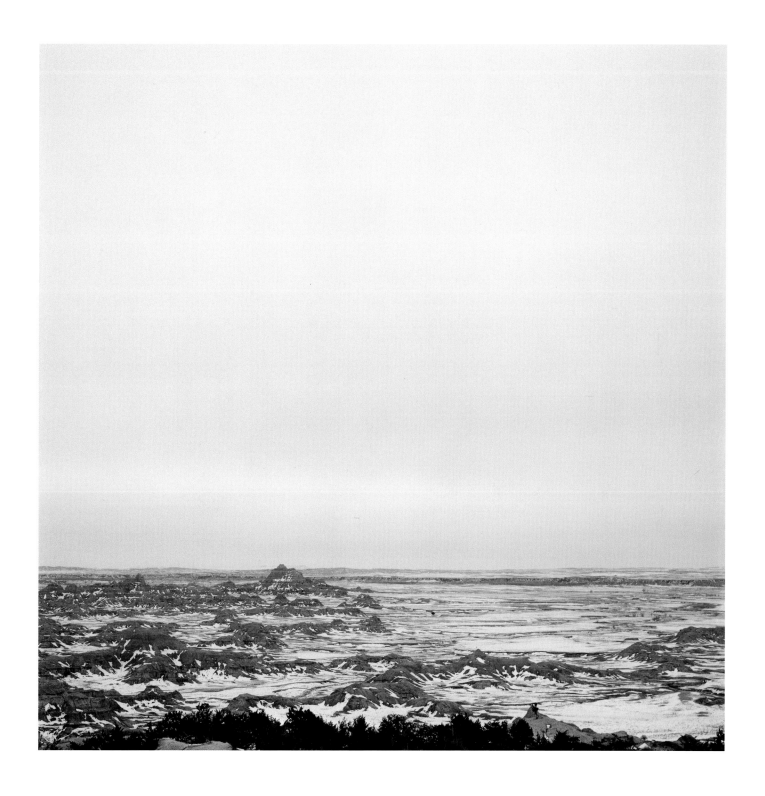

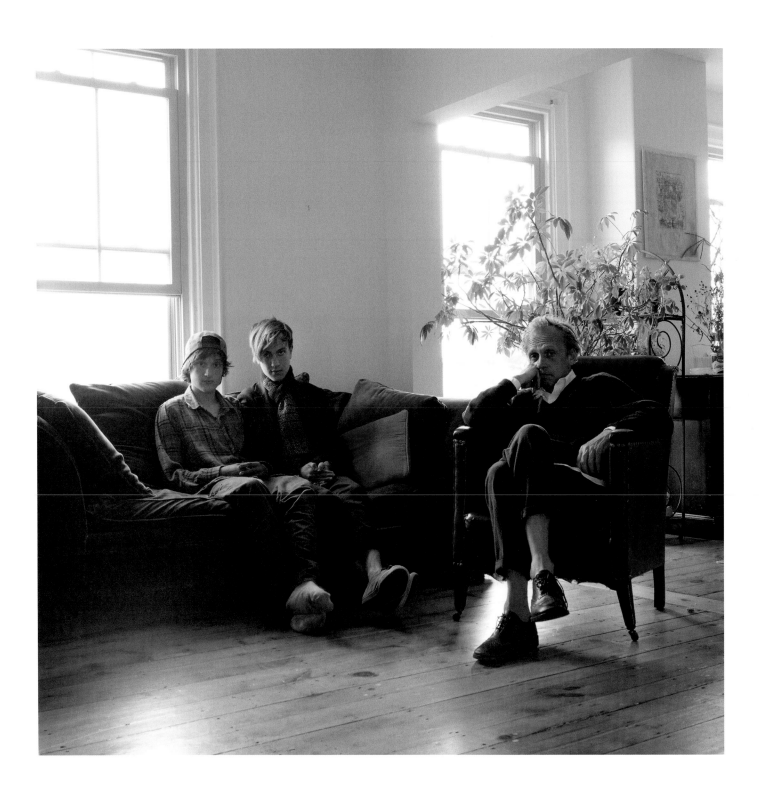

Thank you, friend. Thank you for hearing the world and composing it through images and words and bodies and music. Thank you for dropping out of Julliard and moving to Maine. Thank you for the late nights in our Commercial Street studio drinking $6.99 magnums of Concha y Toro that stained our teeth and lips red. Thank you for Dead Space. Thank you for Sacred and Profane. Thank you for your rolled up pants, Cape Cod gone wrong look, and that gait up Congress Street. Thank you for that thankless survey job. Thank you for your sarcasm. Thank you for your wit. Thank you for your loyalty. Thank you for your Wisconsin charm. Thank you for forgiving me. Thank you for your declarations of love. Thank you for insisting that when I go to Paris, I take a photograph of Modigliani's grave at Père Lachaise Cemetery for you. Thank you for naming your son after my father. Good night, Denis Nye, I'll see you in my dreams.

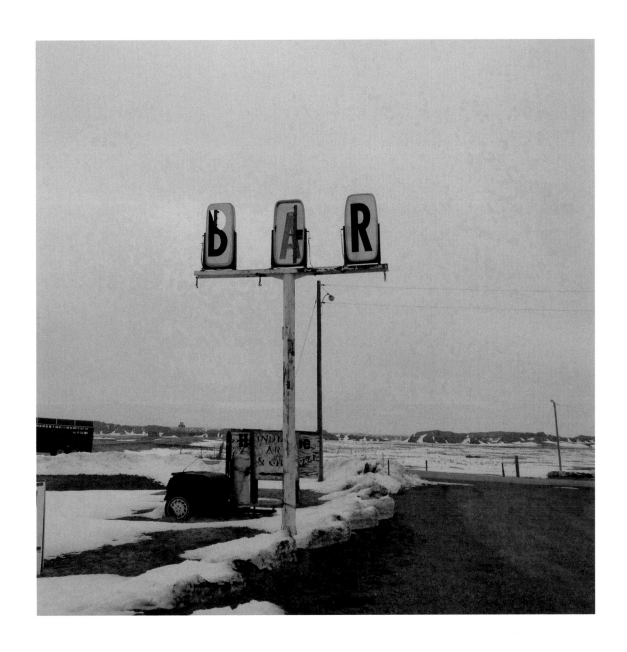

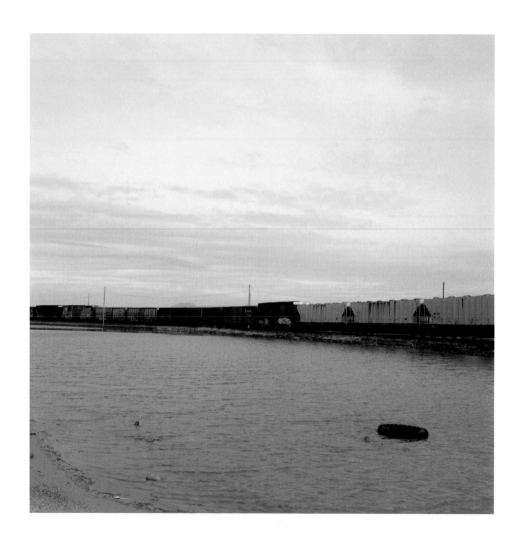

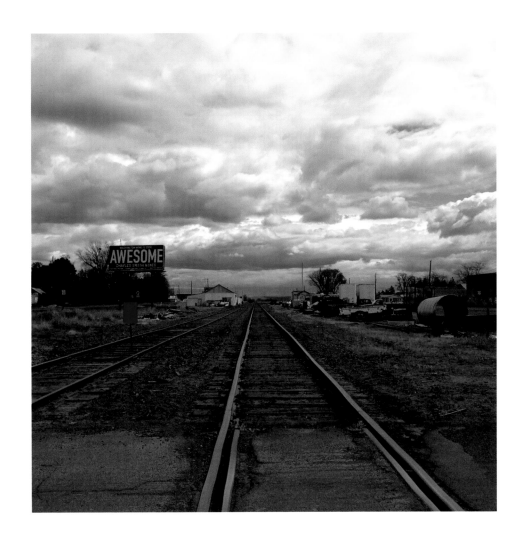

From: Tanja Hollander
Subject: reflections
Date: April 26, 2016 at 6:22 PM EDT
To: Robin Greenspun

I was on a panel at the www conference, and saw Martha Lane Fox give the keynote. She is the Digital Baroness in the House of Lords in the UK. Her mission is to make the workforce gender balanced, get all of the UK online, and reform how government uses technology. She's doing it, and making sure everything is open source, too!

Then I saw Maya Lin speak at Colby College. She talked about the monuments and sculptures we all know and love, but the main focus was her initiatives and foundation to stop climate change. I had no idea she was such an activist.

Somehow, these women are connected to each other and I feel connected to them. I would love to see them at my dinner table.

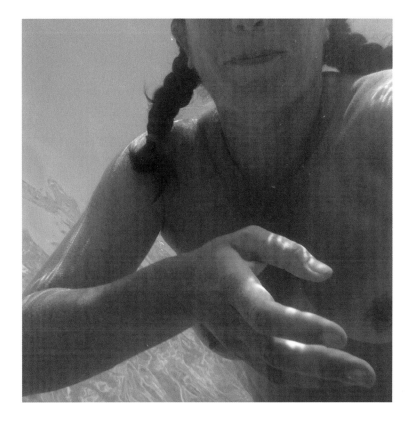

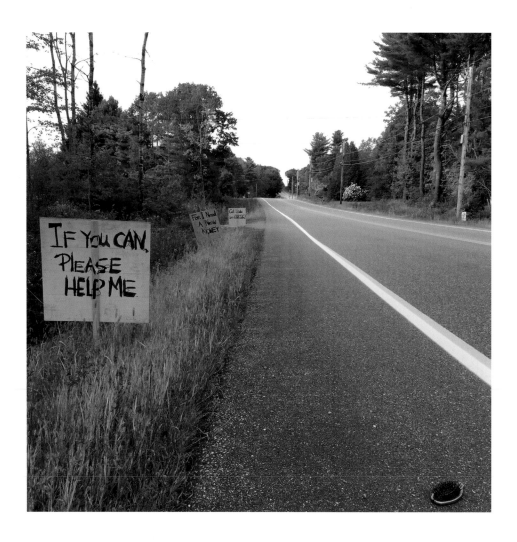

I've driven by these signs a few times now on my way to Portland. Usually I'm going too fast and or in a rush so I don't stop. They're also on a bend in the road, making it difficult to pull over.

Today I slow down enough to make out the word kidney. I do a U-turn in the next driveway and cross the street to read all three double-sided signs.

The first one reads: "If you can please help me." The second: "For I need a new kidney." The third: "Call Linda 207-688-2262."

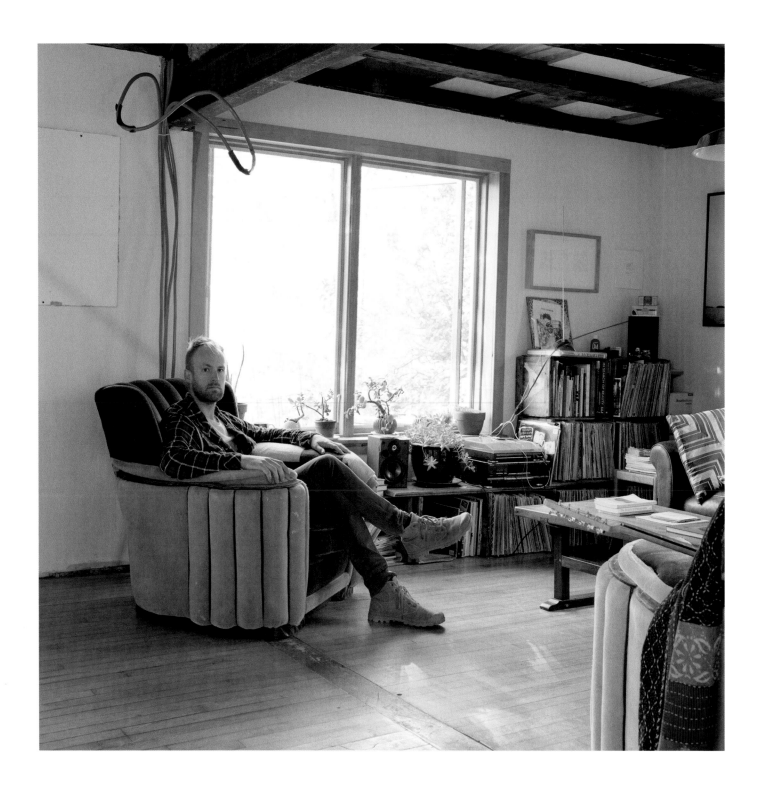

One who allows you to enter (and even rearrange) his own home, life, and yes, wall—facebook or otherwise

A couple of weeks ago, I was working late, preparing to leave town. I heard and then saw a car pull into my driveway. I live in the country, cars rarely pull in, especially at 9 pm. I'm curious, but I also have 911 entered on my phone.

I hear a knock, and there is a young fellow on my doorstep. He introduces himself and I stare at him blankly. Then he says he has an Airbnb reservation for the next three days. I correct him. No, it's for next Thursday. We both take out our phones to check, and sure enough, I screwed up. I don't rent my house while I'm in it.

I've thought and talked a lot about trust while doing this project. About blind faith and humanity. But I haven't had to make a split second decision about trust in my own house. I tell him that he is welcome to stay as long as he doesn't mind that I'm also here, working until I leave on Saturday morning. He agrees that it's better than a sleeping bag on the floor of his new office.

So, I offer him a glass of bourbon. Next thing you know, we're chatting at the kitchen table, becoming friends. #maine

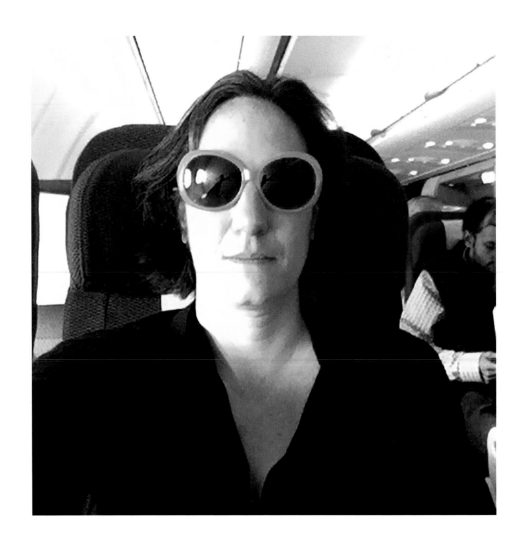

A fella just gave me a travel kit on the bus: Cheez-Its, toothbrush and paste, deodorant, Kleenex, and baby socks. #texas

ACKNOWLEDGMENTS

This book was made by a group of ridiculously smart women.

The team of ladies who worked tirelessly, burned the midnight oil with me, and treated this book as if it were their own: Luna Cardilli, Ljudmila Socci, and Tanya Whiton. The ladies who wrote essays from the many conversations we've had about art and friendship: Elisa Albert, Jacoba Urist, and Wendy Richmond. Brittany Marcoux, whose smarts, organizational, and Photoshop ninja skills I could not live without. Denise Markonish, who trusted me early on, pushed me gently beyond what I knew I was capable of doing, and wrangled this book into being. Sarah Devlin, who has known and edited my writing for so long, she knows what I'm trying to say before I say it. Robin Greenspun, who nurtured me, created a film about the project, and made this book possible. And she introduced me to Tarissa Tiberti at MGM Resorts Art & Culture, who understood AYRMF immediately.

Copy editor: L. Jane Calverley. Proofreader: Paulette Wein. Production: Jenny Wright.

A giant thank-you to everyone who let me photograph them and get a glimpse into their lives.

This exhibition would not have gone up on the walls, and a book would not have been made, without the health care I received from Planned Parenthood of Northern New England, Equality Health Center (Concord, NH), and the Affordable Care Act.

My incredibly patient family: Toby + Lucky Hollander, Emma Hollander, Amanda, Katy + Henry Hollander, Chanelle Irakoze, Peter + Daryl Ellef, Tara Ellef + Chuck Cardillo, Bubba, Trey + Taylor Ellef, and Christine + Jack Kurtz.

Jenny Ewing Allen, Colin Dusenbury, and Siri Kaur, who talked me down from too many trees to count. I received great advice from Joyce Bernstein, Stephanie Delman, Natalie Diaz, Richard Nash, Susannah Richards, Larry Rosenthal, Pamela Rosenthal, Joshua Shenk, Kio Stark, and Sam Wertheimer. My friends: Keliy Anderson-Staley, Dr. Mary Bouxsein + Ed Doyle, Hasan Elahi + Grace Gordy, Peter Fallon, June Fitzpatrick, Laurie Frick, Danny Greenspun, Lynn McArdle, Katie Fitch, Joe, Winona + Delila Wardwell, Brett Johnson, Johanna Moore, Barry O'Meara, Emily Sunderman, Michael + Carter Lee, and Susan Wiggin. Additional gratitude to Allie Foradas, Larry Smallwood, Joseph Thompson, and the entire staff at MASS MoCA. At MGM Resorts International: Jim Murren and Jim Beyer.

I was in Paris during the 2015 attacks with Jeff Sharlet—we worked collaboratively reporting on Instagram, writing, photographing, and editing together. I excerpted our collaboration on pages 150 to 155. On the night of the attacks, and the following day, we were with Sarah Khatry. I am grateful for her fearlessness, keen observations, and new friendship.

I am also indebted to the many people who purchased commissions and crowdfunded the project and the early stages of the book.

CONTRIBUTORS

Elisa Albert is the author of *After Birth, The Book of Dahlia,* and *How This Night is Different.* elisaalbert.com

Denise Markonish is curator at MASS MoCA in North Adams, where she organized *Nick Cave: Until; Explode Every Day: An Inquiry into the Phenomena of Wonder; Teresita Fernández: As Above So Below; Oh, Canada: Contemporary Art from North America.*

Wendy Richmond is a visual artist, writer, and educator whose work explores issues of health, technology, and creativity in contemporary culture. wendyrichmond.com

Jacoba Urist regularly writes about contemporary art for *The Atlantic.* She has also covered art and architecture for *The New York Times, New York* magazine, and *Smithsonian Magazine.*

To learn more about the entire project, visit the archive at areyoureallymyfriend.com. The artist is available at @tanjahollander.

Published by
MASS MoCA
1040 MASS MoCA Way
North Adams, MA 01247
massmoca.org

With the support of

Design and Concept by Luna Cardilli and Ljudmila Socci, Black Fish Tank Ltd

Text and Images ©2017 Tanja Hollander

Cover design by by Luna Cardilli and Ljudmila Socci, Black Fish Tank Ltd

Edited by Tanya Whiton

Essays ©2017 by Denise Markonish, Elisa Albert, Jacoba Urist, and Wendy Richmond

Copy editing by L. Jane Calverley

ISBN: 978-0-9700738-7-7

Printed in Canada